The Henryton Project

Amy McGovern & Timothy McGovern

This book is dedicated to all the souls that resided at Henryton Hospital Center over the many years it was an acting hospital. You are not forgotten.

THE BEGINNING

From my daughter's point of view…….. I heard about Henryton from friends and strangers, rambling on about the eerie buildings and graffiti-stricken walls hidden behind "No Trespassing" signs and trees. It was truly a mystery I for one didn't care about. But a friend and I got bored one warm night and found ourselves tagging along with a few friends to see what all the fuss was about. We parked in an area closed after dark and walked forever down the railroad tracks that crosses Marriottsville Road. There wasn't much to see but trees and the occasional squirrel or rabbit running through the bushes. But when we got there, I can't even explain to you how much I wanted to leave. The place was creepy, no doubt. We started at the power plant, down a hill from the main buildings, and worked our way around in the dark, being careful not to fall in bottomless man holes and gross puddles of mystery substances. I was careful not to stare at one spot for a long period of time, in case my mind decided to play tricks on me. But as we approached the main buildings, I couldn't help but stare at the beautiful mess left here. The buildings towered over everything in sight; plaster and roofing in piles around what use to be a place of society. I wouldn't dare go in though, and honestly, I still don't blame myself. After that, Henryton stayed at the back of my mind until passing over those railroad tracks one day a few weeks later. My tongue slipped and I told my dad all about the place, leaving out the part that I had gone there. He had slight interest and didn't really seem to care. I don't remember how word about it got to my mom but when it did, it opened up something new in her eyes. It wasn't long until I had my whole family dragged there to see for themselves (in the day time of course). What you're now reading is the beginning of my mom's exploration of anything haunted, old, or just plain forgotten. And it all started from the abandoned buildings off of Henryton Road
Emily McGovern March 28, 2011

CONTENTS

	Acknowledgments	4
1	History of Henryton	5-10
2	From Years Gone By	11-25
3	Diary History	26-28
4	Mysteries	29-30
5	Journal Entries	31-50
6	Save Henryton	51-52
7	Photos	53-60
8	Neighbor of Henryton	61-62
9	Random Shots	63
10	About the Author	64

ACKNOLEDGEMENTS

Thank you to all the people that help make this book a reality. Thank you to all the supervisors and crew at the Henryton Hospital Center demolition site. Without all your wonderful help, this would not be possible. You all are very much appreciated. While photographing the demolition, the entire crew was fantastic to us.

Asst. Secretary Bart Thomas
Department of Health and Mental Hygiene

Joe Nichols
Resident Construction Inspector
Department of General Services

Patrick Fink
RETRO

Aaron Zinkhan
Green Street Environmental

Building Demolition Machine Operator
Dionicio - he is in just about every demo shot

Jerimiah A. Sabi
Deputy Director
Office of Capital Planning, Budgeting and Engineering Services
Maryland Department of Health and Mental Hygiene

Bill Oursler – former Henryton neighbor

All my contributing friends with photos:
Betty Fowler
Nathan Kay
Dawn Robinson
Rick Cannedy
Liz Cusick
Guy Housewright
Deborah Felmey

And to my loving family:
Tim McGovern- the photographer
Kassi McGovern – the proof reader
Emily McGovern – the detective

CHAPTER 1 HISTORY

Henryton State Hospital, or the Henryton Tuberculosis Sanatorium, was located in Marriottsville, MD, in Carroll County. It was surrounded by the beautiful Patapsco Valley State park, tucked back amongst the trees and rolling hills, slowly engulfing its towering white band of brick buildings over time.

Since there are no history books about Henryton, searching for accurate information was a challenge. The internet was full of wild ideas of what people thought life was like at the hospital, but no dead-on facts, which is how this book came to be written.

The Maryland State Archives has the following information on file:

"The Henryton State Hospital was created by an act of the General Assembly. In 1918, Chapter 148, Section 180 directed the Board of Managers of the Maryland Tuberculosis Sanatorium to establish and maintain proper facilities for the care and treatment of colored patients suffering from tuberculosis. The act also gave them the authority to acquire and build the necessary buildings.

The hospital first opened in 1923 and established under Chapter 464, Acts of 1922. The hospital, the Post Office, and most of the land is located in Carroll County. However, some of the property extends to Howard County. The facility included 175 acres of wooded land. A hospital building, administration office, heating plant and several other buildings used to house staff were located on the property. The hospital had its own sewage plant but purchased electricity from the Gas & Electric Company and water from Springfield Hospital. The hospital treated colored patients, men, women and children. It also had a training school to instruct students to become registered practical nurses. The Maryland General Assembly budgeted the hospital $270,000 in 1938 for the construction of new buildings to house more than 200 patients as an increase in tuberculosis patients grew during the 1930's. By the time the buildings were finished in 1946, the number of patients with tuberculosis had dropped.

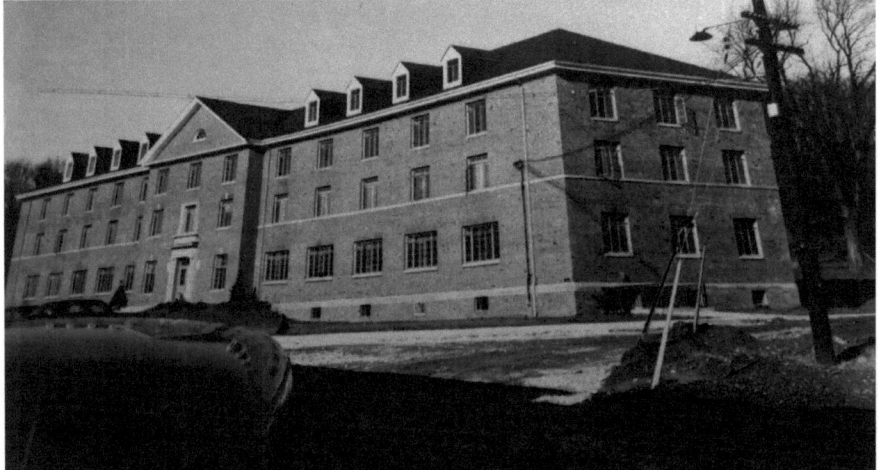

In 1947, The General Assembly, under Section 94A, Article 43, abolished the Maryland Tuberculosis Sanatorium and placed all Tuberculosis hospitals under the State Board of Health. The Superintendent was responsible for all administrative duties of the hospital under the direction of the Chief of the Division of Tuberculosis Services of the State Department of Health.

Until 1947, all State tuberculosis hospitals were under the direction of the Board of Managers. All budgetary decisions were under the central control of the Superintendent of the Sabillasville Sanatorium. After 1947, the Board of Directors were dissolved and the Chief of the Division of Tuberculosis Services was to take gradual control of administrative duties while the Superintendent of Sabillasville still held some budget and personnel decisions until a total reorganization took effect. All activities concerning medical treatment of patients except nursing and attending care, was under the direct control of the Superintendent of the hospital. All nursing and attending care activities were under the control of the Superintendent of Nurses who is under the responsibility of the Superintendent of the Hospital.

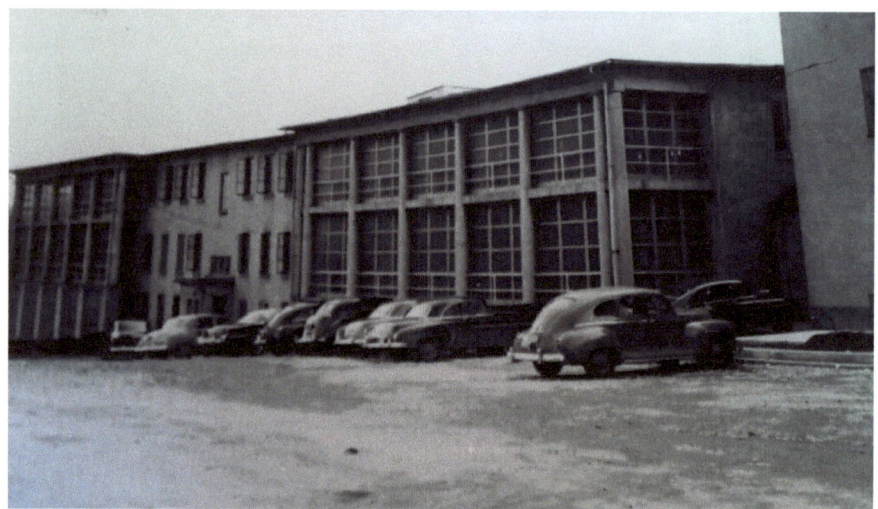

On February 2, 1962, Governor Tawes recommended to the Legislature to approve "the conversion of Henryton State Hospital from a tuberculosis treatment facility to one which will provide services to the mentally retarded." On September 28, 1962, the newly created Maryland Board of Health and Mental Hygiene approved that Henryton would be considered for providing individual care and treatment of "trainable" mentally retarded patients during an interim period until it was included into the statutes of the agency.

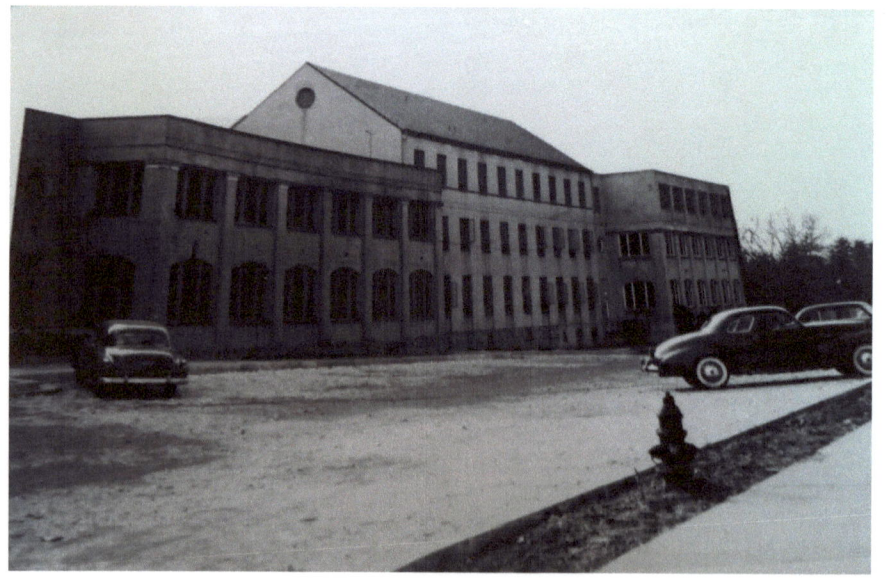

The hospital ended the operations of being a tuberculosis treatment center and was to be converted to a facility to train and assist those, "severely and profoundly retarded ambulatory residents ages eighteen and over." The hospital was directed towards the training of each patient to care for themselves with the eventual goal of being able to

return to the community or live more effectively in an institutional setting.

On August 27, 1962, 27 male patients were first admitted for the day care program. An orientation for the Henryton staff was conducted at Rosewood State Hospital in July 1962 for the preparation of caring for mentally disabled patients. A particular emphasis was placed on helping residents in areas of self-care, self-reliance, and socialization through regular attendance in music and rhythm therapy, arts and crafts, home economics and work therapy. On October 1, 1962, all the patients who participated in the Day Care program were admitted as residents of the hospital. Soon afterwards, regular admissions of both male and female patients from Rosewood and fourteen females from Crownsville started. The average age of the first 24 patients was 34. Most had been institutionalized all their lives.

Leaders assisted in proper table manners in using a knife, fork and spoon correctly. After breakfast, the group would then go back to their living quarters to make their beds and clean their rooms. After all this was completed, the group By October 13, 1962, 290 patients resided at Henryton. At that time, the hospital was set up to house 330 patients. Once further renovations were completed a maximum amount of 400 patients could be treated. Admission to the hospital was handled by the Mental Retardation Administration under the Maryland Special Services. New patients, as well as patients from other hospitals, mainly from Rosewood, would be able to receive care. Criteria for admission were continence, ambulation, the ability to follow simple direction and the absence of severe behavior problems. Henryton also ran a respite care program with admission by special request.

The habilitation program was considered very successful. A group of 14 patients would make a group. Each group had one person in charge called the group leader. The group leader would assist helping patients in their group by being more aware of their hygiene and personal appearance. The group would then attend breakfast where the group would spend the rest of the day in planned programs in recreation, music therapy, industrial therapy and domestic science. Also, other activities in assisting in personal habits and motivation were used. There were also some religious and volunteer activities available. The program was considered so successful that one –third of patients were allowed to go home. Extended and short-term home visits were encouraged for other patients. Families were encouraged to take relatives home and were given guidance in helping to accept them. Foster care was provided for those patients that did not have home care available. Social workers were available for consultation and guidance.

During the 1970's and early 1980's, popular American mindset changed from institutional care to more of an outpatient and home care. These ideas lead to a decrease in residents at Henryton. In 1984, the Maryland Department of Health and Mental Hygiene decided to end the training program because of low numbers in enrollment. By 1985, Henryton had fewer than 100 patients and operations in the center were being phased out. The fall of 1985 saw the facility empty and the hospital closed. For fiscal 1986, Henryton did not exist on the Department of Health and Mental Hygiene budget." The black and white photos in

this History chapter are from the Maryland State Archives, unknown photographer.

http://guide.mdsa.net/history.cfm?ID=SH243

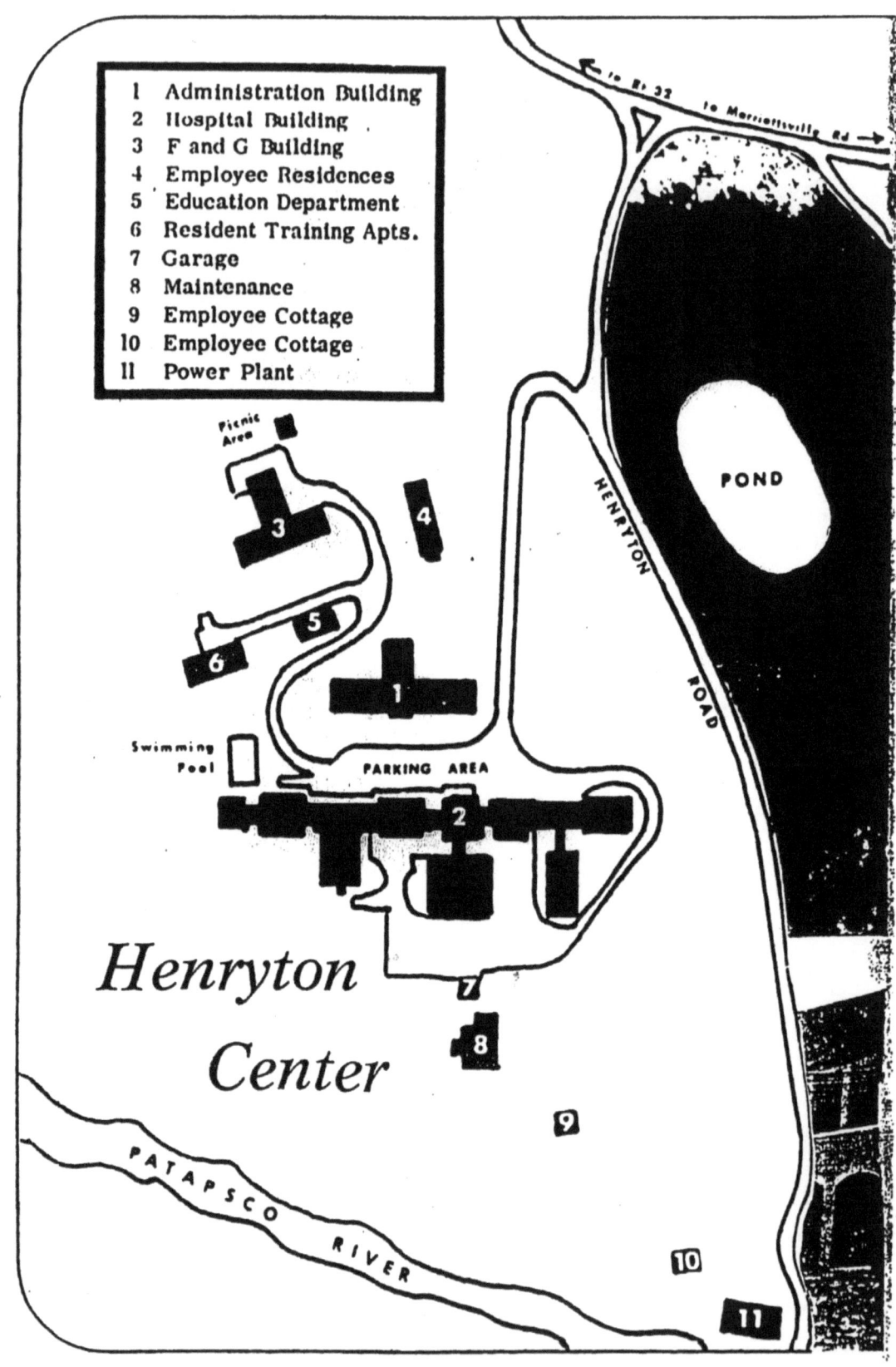

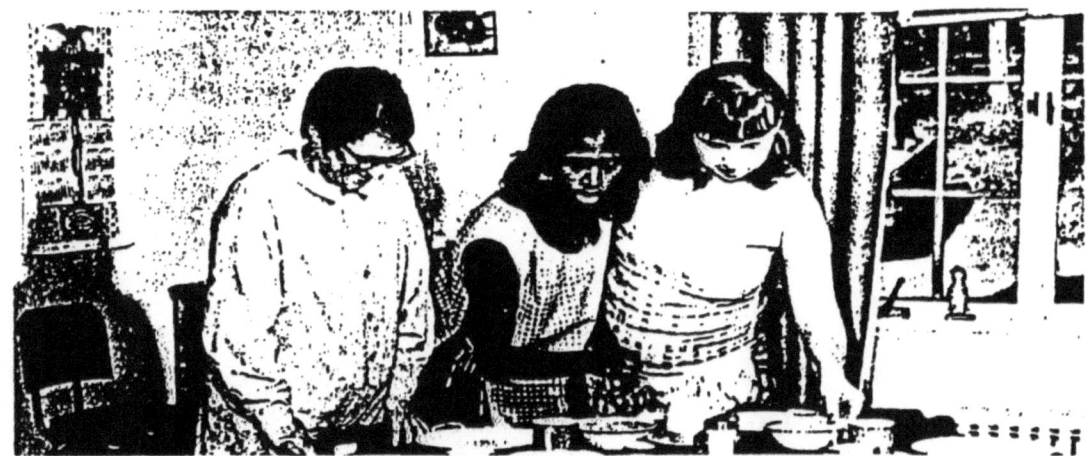

An integral part of the total educational training program are the **Living Units.** There are five living units that serve as residences for the men and women residing at Henryton. These halls are light and roomy and there are some private rooms. The capacity of the living units is as follows:

Nichols Hall	81 residents	Male	First Floor
Hughlett Hall	104 residents	Female	Second Floor
Diggs Hall	91 residents	Male	Third Floor
Hastings Hall	62 residents	Coed	First Floor
Martz Hall	62 residents	Coed	Second Floor

The residents are responsible for the care of their furnishings, wearing apparel and other personal items such as radios and televisions which are contained in individual lockers and bedside stands. Some areas have a modern type bed, locker and wardrobe combination. This item is being purchased on a projected basis for the entire Center. Fully equipped bathrooms and clothing rooms are adjacent to each living unit and personal hygiene and good grooming are supervised by the staff. These are day rooms for small group activities and television viewing. The residents participate in activities in the Recreation Center or the Auditorium such as church services, movies and canteen which are available throughout the week. Dances, plays, parties and other community sponsored events are provided.

The **Beauty and Barber Shops** greatly assist in meeting the personal hygiene and grooming needs of the individual resident and also provide special hair and scalp treatments as needed. Through such services greater self-awareness is promoted and the individual gains a greater appreciation of self-care responsibilities.

AN ORIGINAL PAGE FROM A HENRYTON PAMPLET

CHAPTER 2 THE YEARS GONE BY

Main Building / Original Administration Building

The front and middle of this building was the original administration offices. It had wood floors and lots of bathrooms. It also housed nurses, and was around 13,200 square feet.

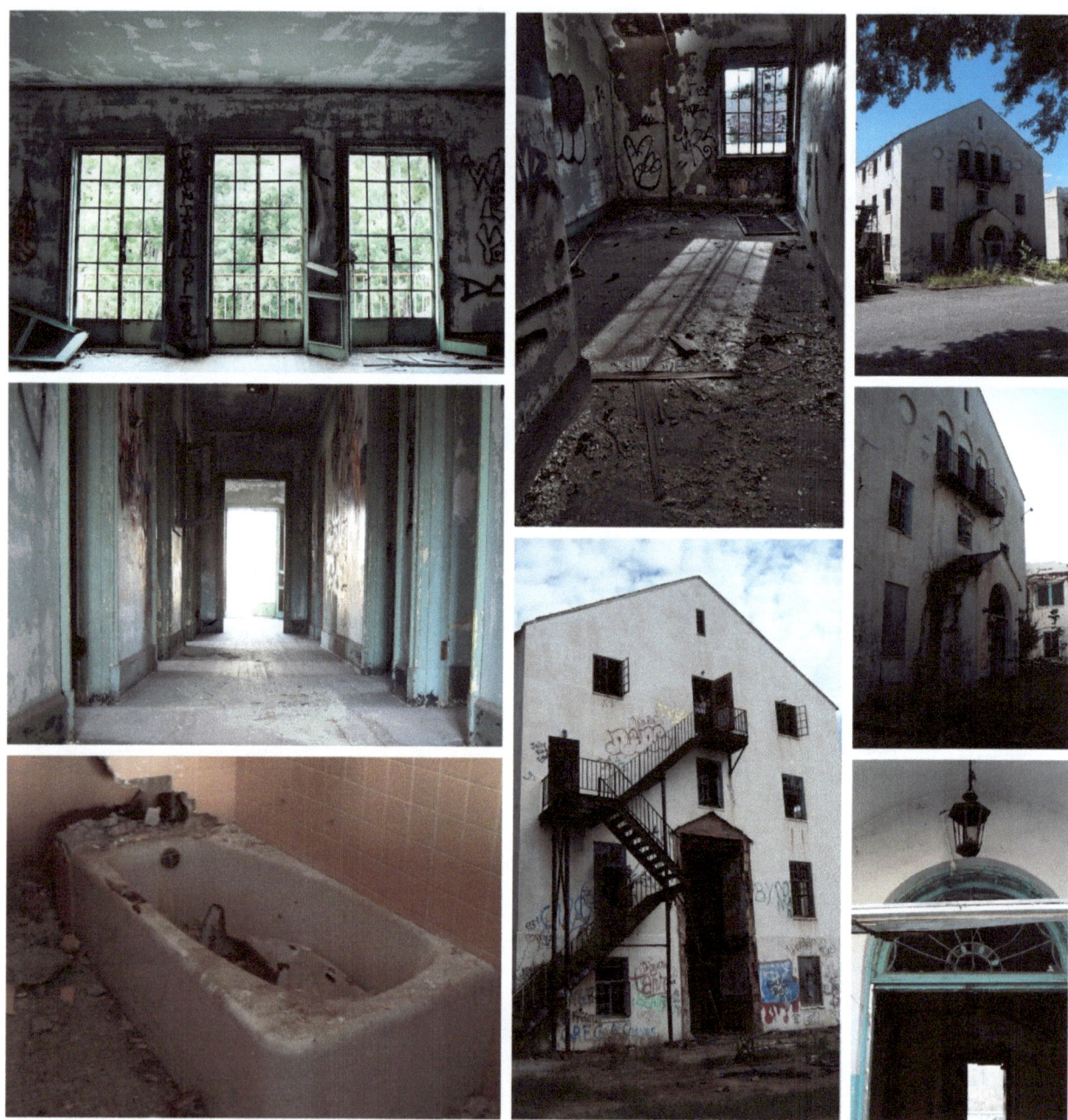

Nurses Home – Later called the Administration Building

Completed in 1928, this building was originally sleeping rooms for nurses, and also had a reception area, lounge, school rooms, offices, and a laboratory. No one knows when the word "Administration" was added to the front entrance. It was around 10,780 square feet.

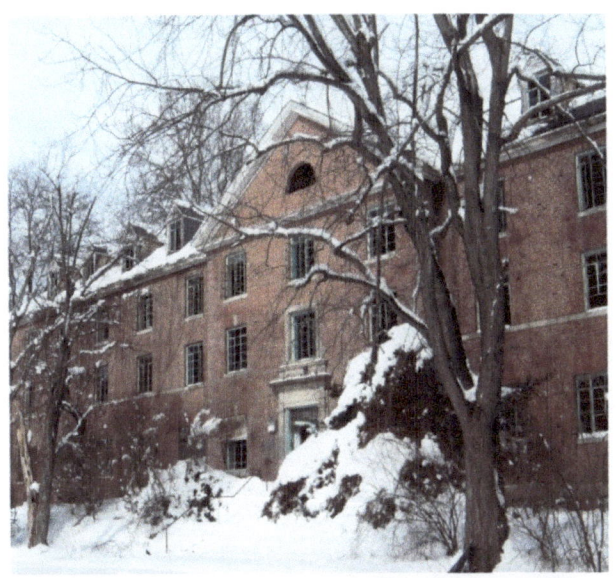
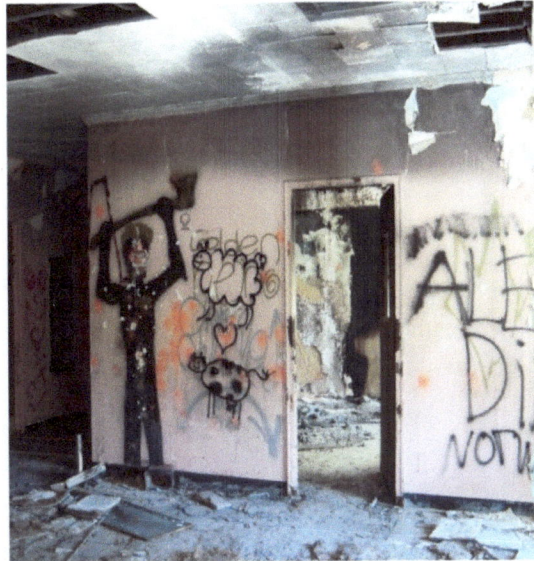
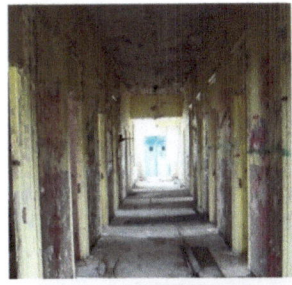
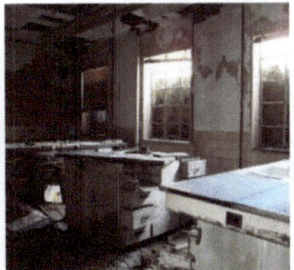
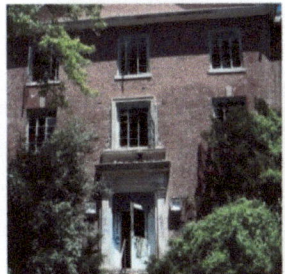

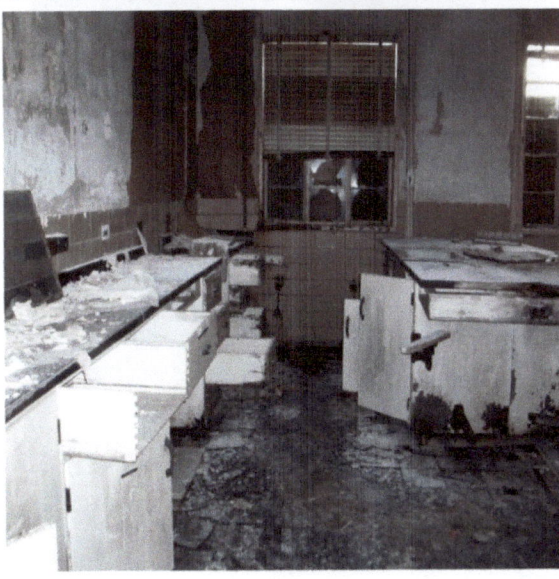
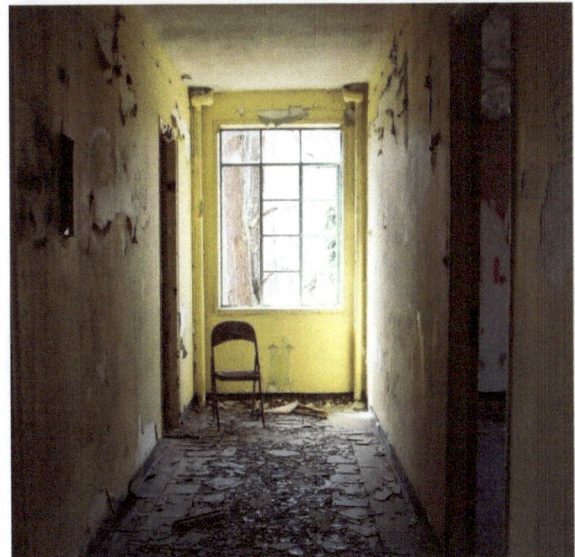

East Wing

The East Wing was to the left of the white Main building. It had patient rooms, a paint room, a maintenance room, walk in refrigerator, post office, and a laundry room. The old insurance maps state that the pink room was the morgue. This building also contained an elevator and was around 12,495 square feet.

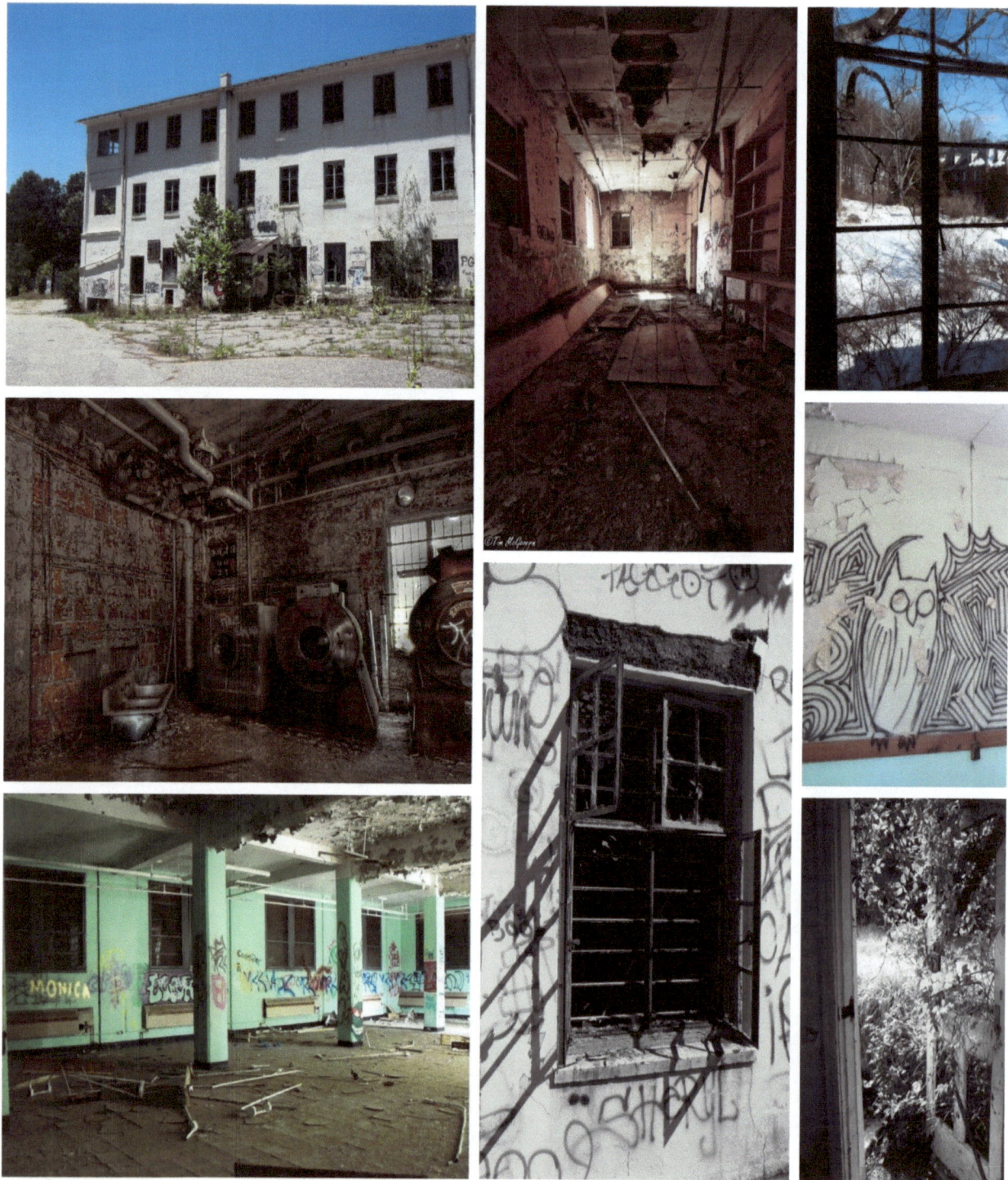

West Wing

This building was mainly the hospital ward, on all four floors. The first floor had X-ray rooms and treatment rooms. In 1921, it was built to follow popular sanatoria concepts for large treatment areas, with large, open wards that projected open-air porches. This also had an elevator and was 19,840 square feet.

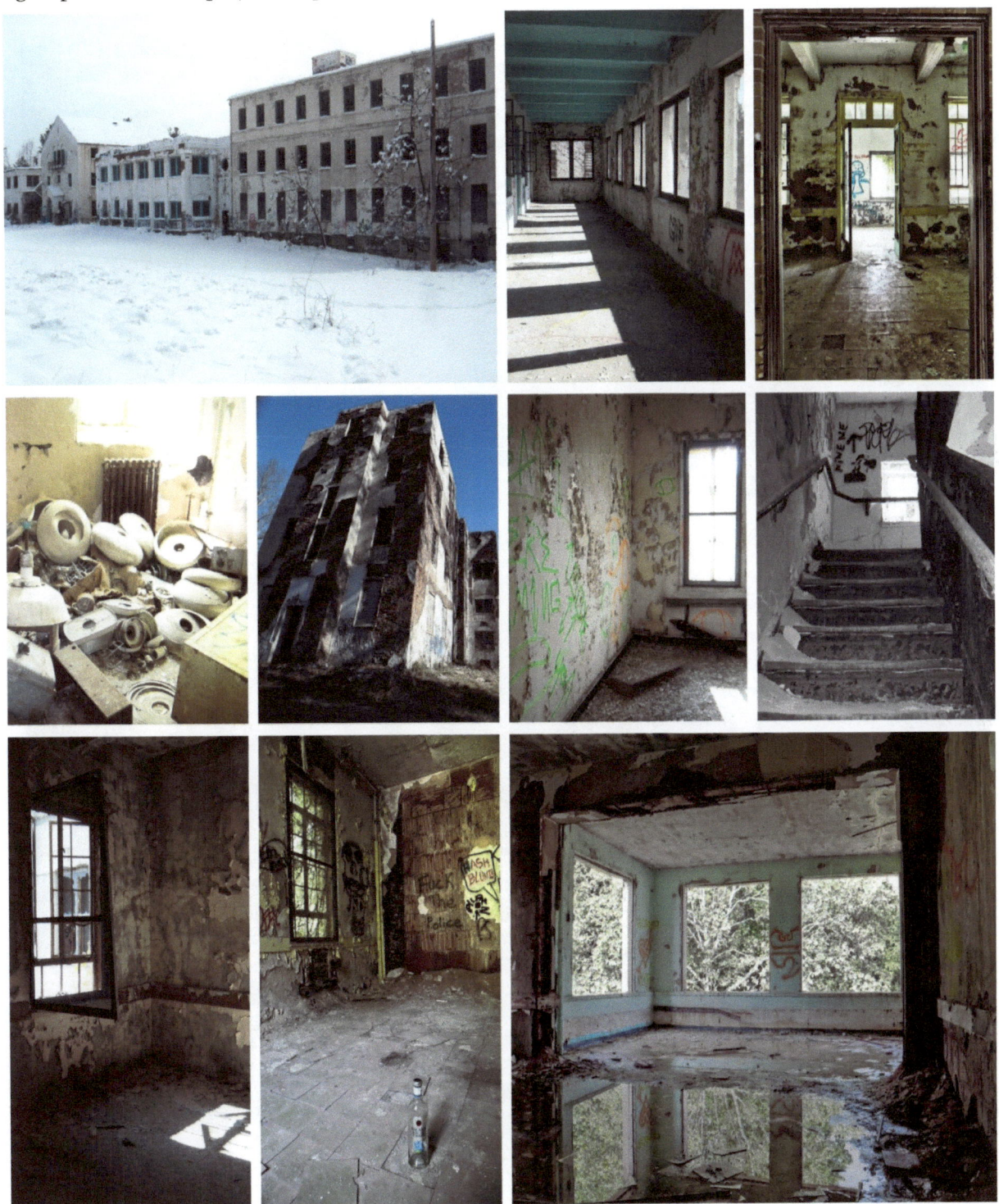

The Power House

This two story brick utilitarian building with a flat roof was built in 1938. It had a large smoke stack that stood a staggering 95 feet high. It provided all power to the buildings.

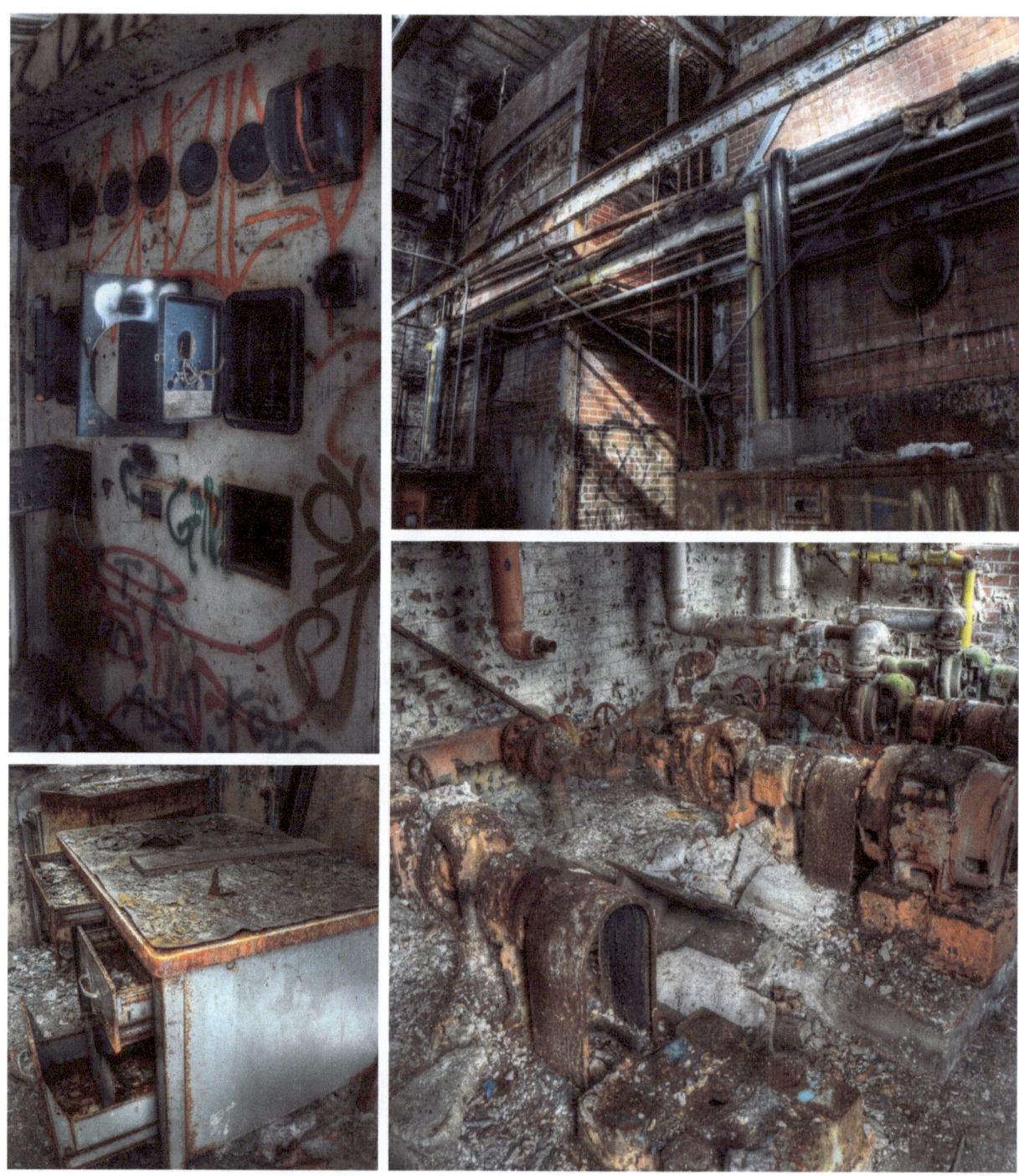

These inside shots were taken by Dawn Robinson

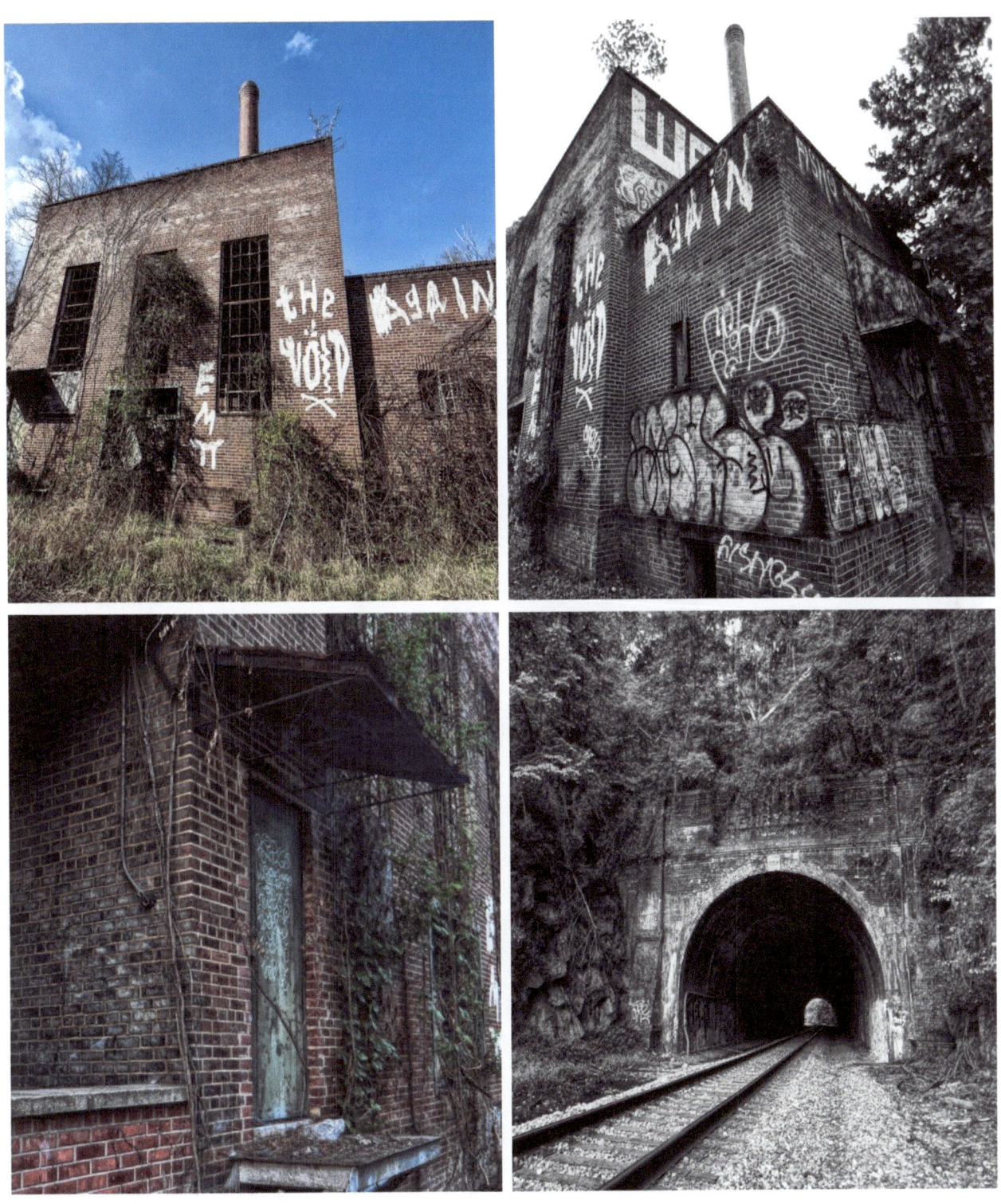

The Power Plant was located next to the oldest active train tunnel in the United States, The Henryton Tunnel, which runs on the "Old Main Line". **Photos by Amy McGovern.**

Cafeteria and Theater

The cafeteria and theater were burnt in a massive fire in December of 2007. It took over three hours and eighty firefighters to put out. Later, the State of Maryland removed the two buildings. The only photo I could find was from Dan Haga, in his book *Urban Atrophy*. The archives only have a written sketch of the buildings.

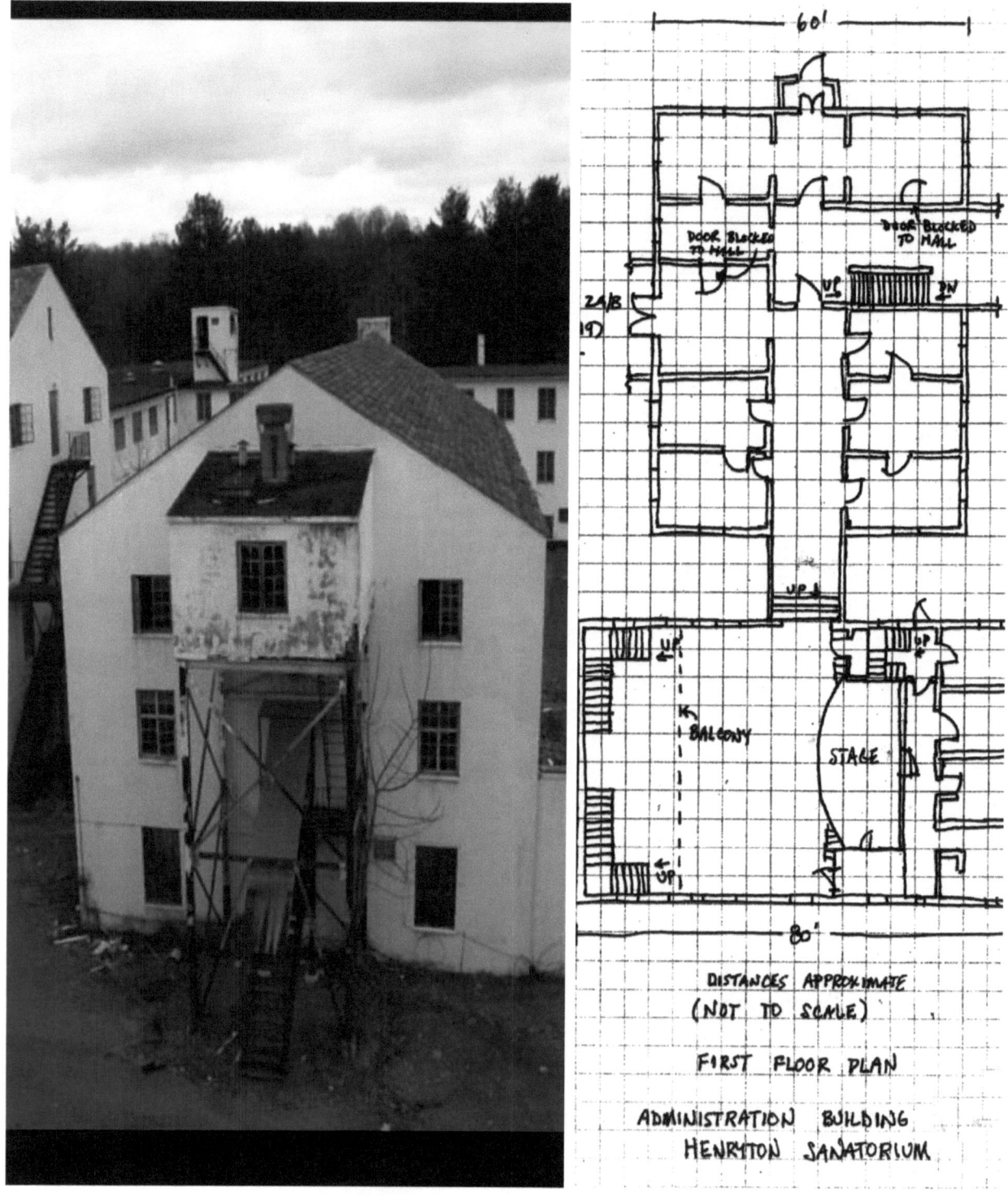

Staff Cottage

This building contained sleeping rooms for hospital staff. It was a split-level building. The first floor had two apartments, with knotty pine walls and ceilings, while the basement accommodated a club room for the staff. It measured to around 4140 square feet. This was hit by lightning in April 2012 and the roof was destroyed.

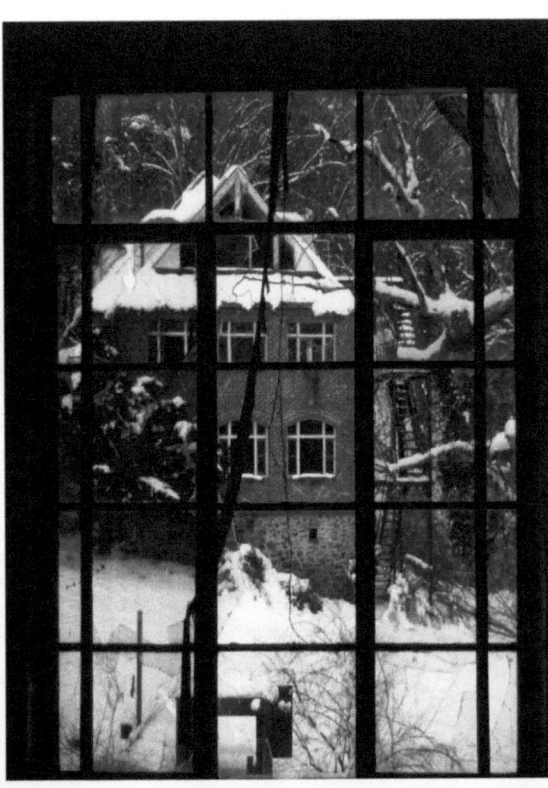
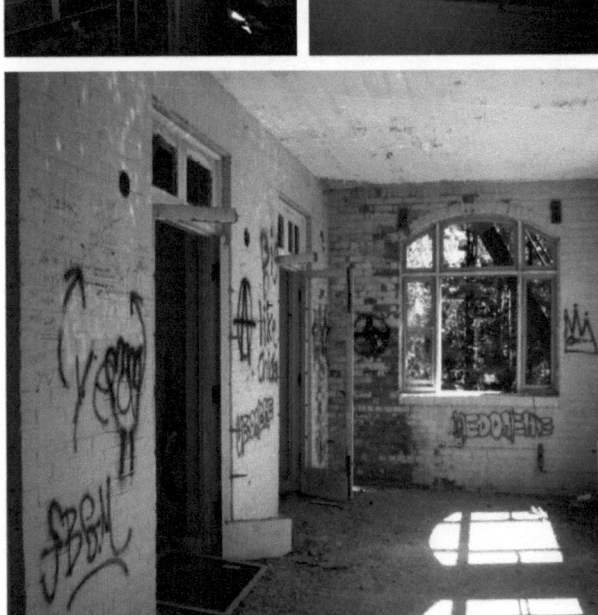
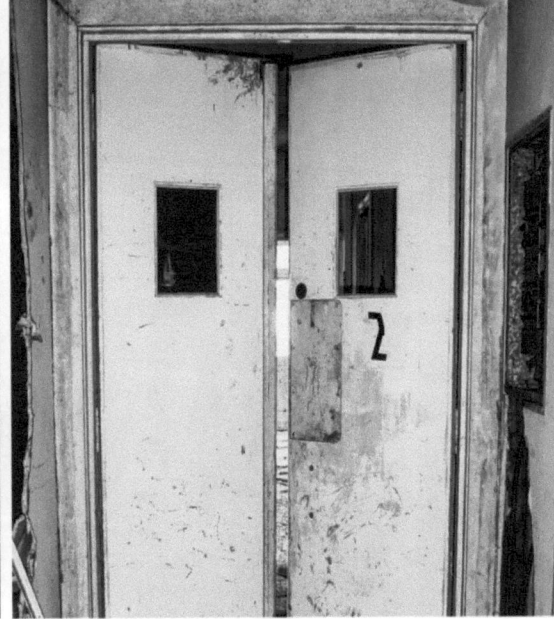
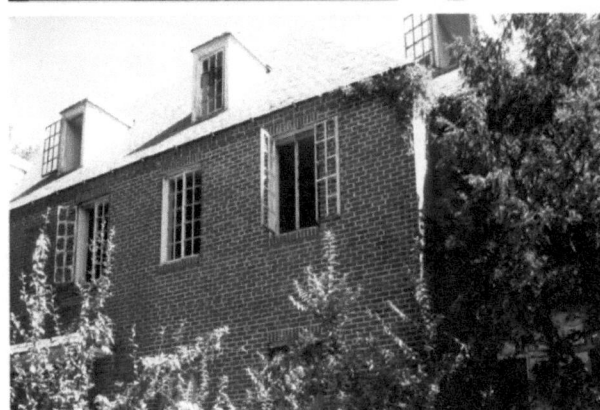

Nurses Quarters and Children's Building

In 1934, this building was an ambulatory care facility that housed around 50 children. The children's section was closed in 1946 due to a lack of children to care for, and was turned into therapy building to rehabilitate patients. It was 7,020 square feet.

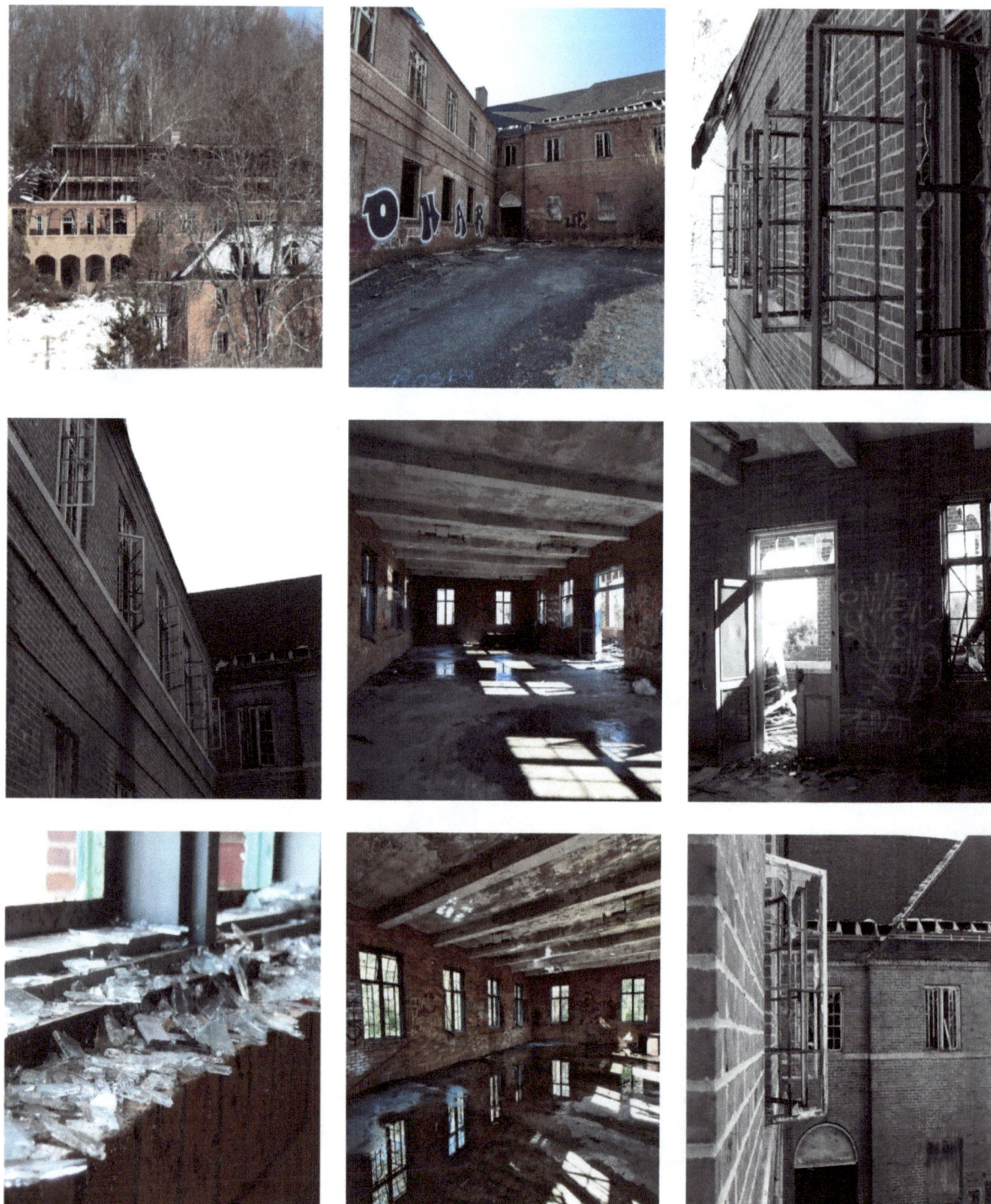

Attendant's Cottage

This building never had a front on it when we first started going Henryton. I have yet to locate an original photo. The Maryland Historical Trust says it was built in 1940. It housed the staff and later in 1946, was changed to a rehabilitation building.

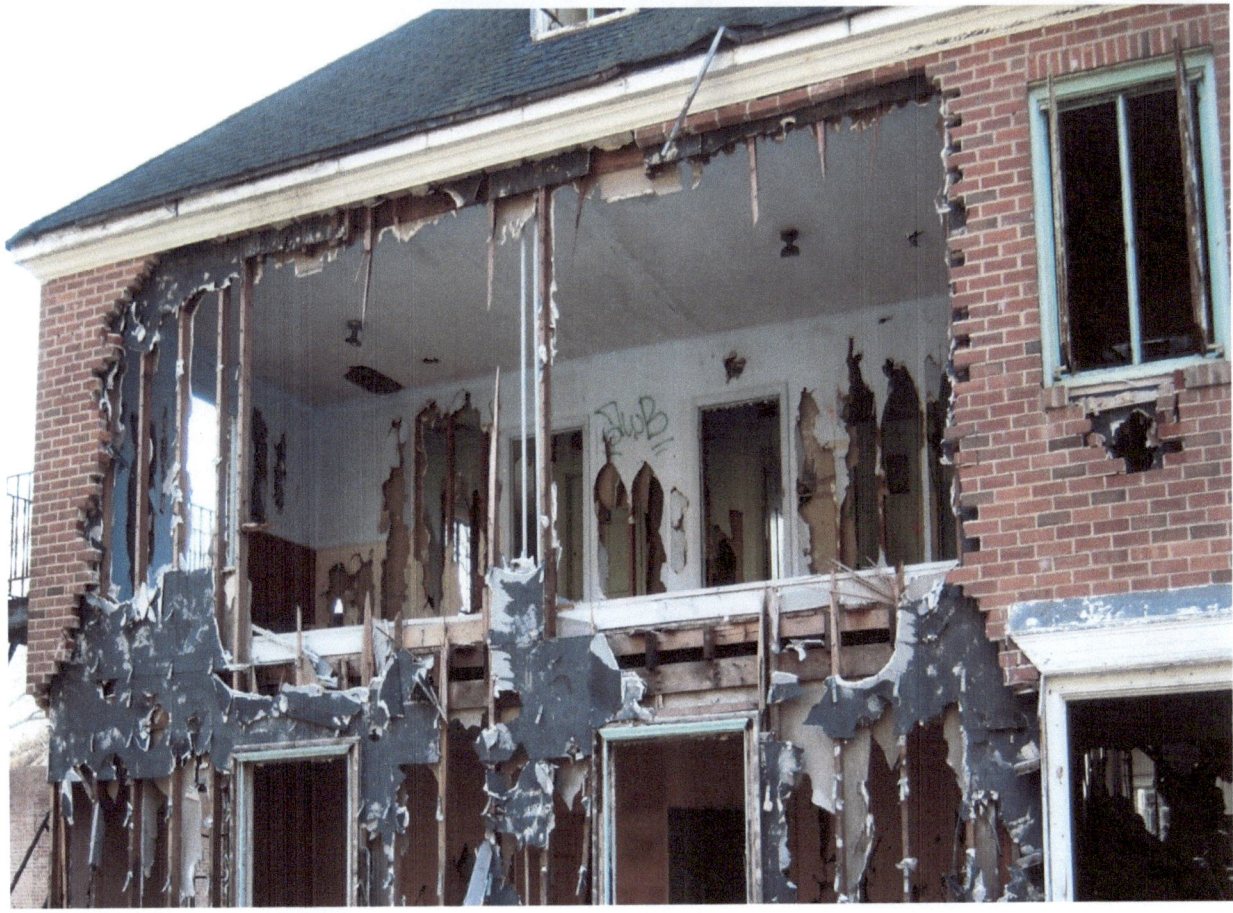

Engineer's House

This was a two story gable cottage, built around 1940. It was burned by arsonist in March of 2013.

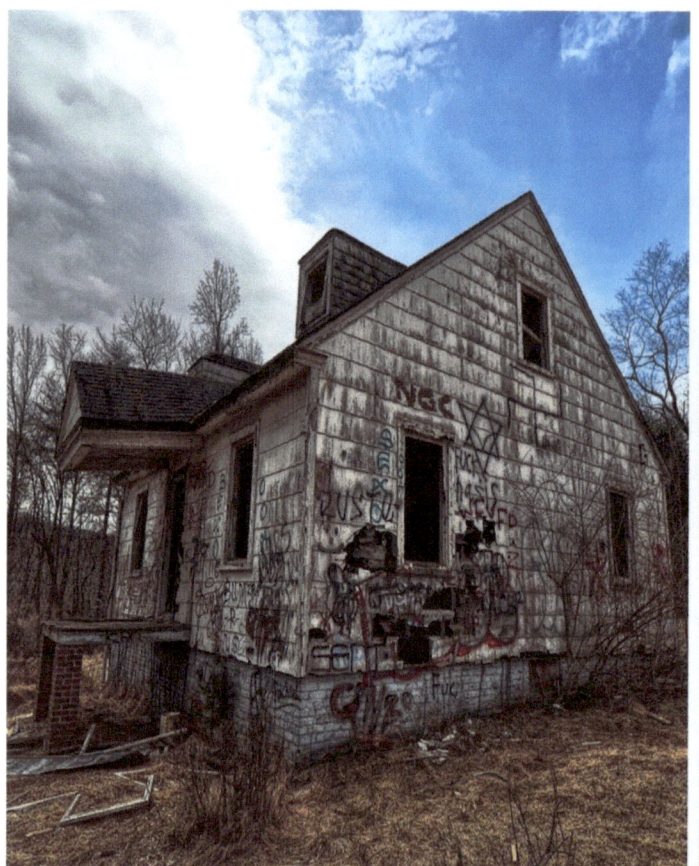
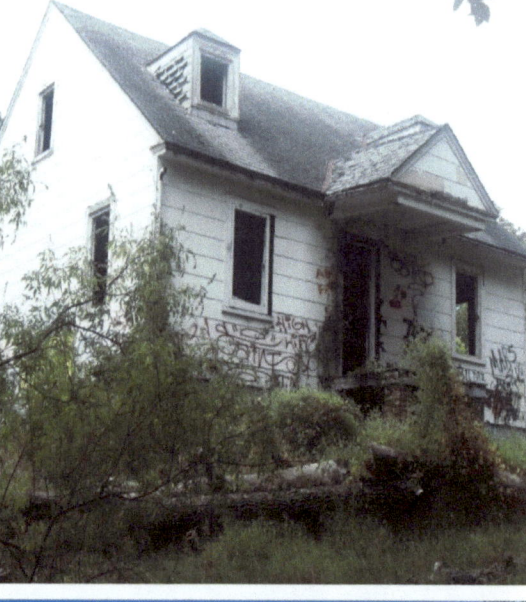
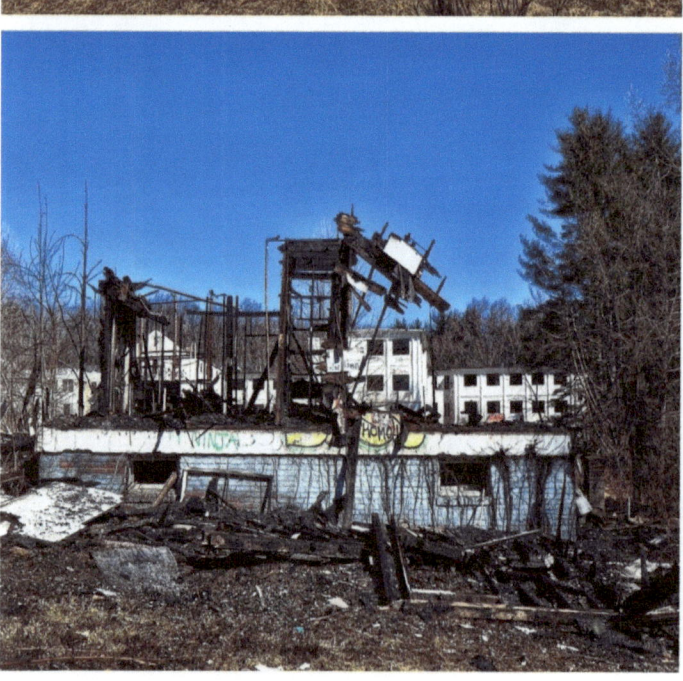
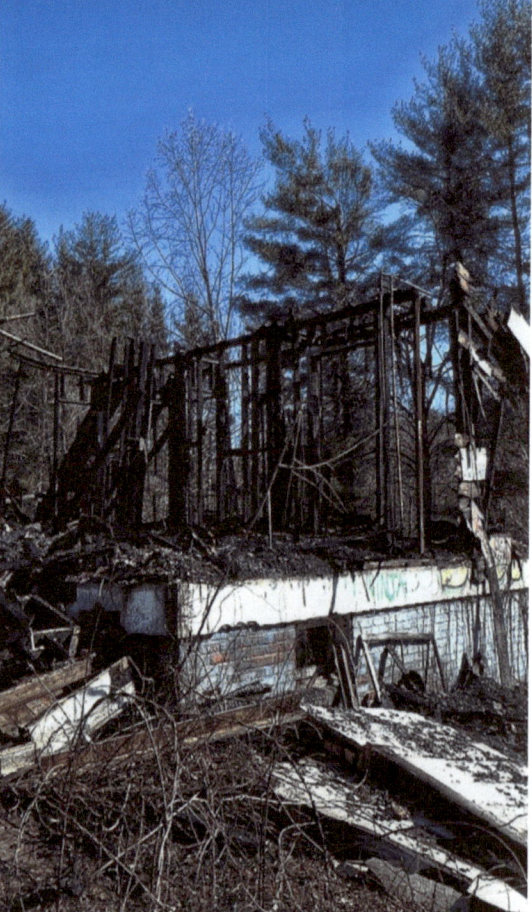

Garage and Maintenance Shop

Both the garage and maintenance shop were built in 1940. The garage had five work bays. Since we had visited Henryton, there was an old Thunderbird inside the shop.

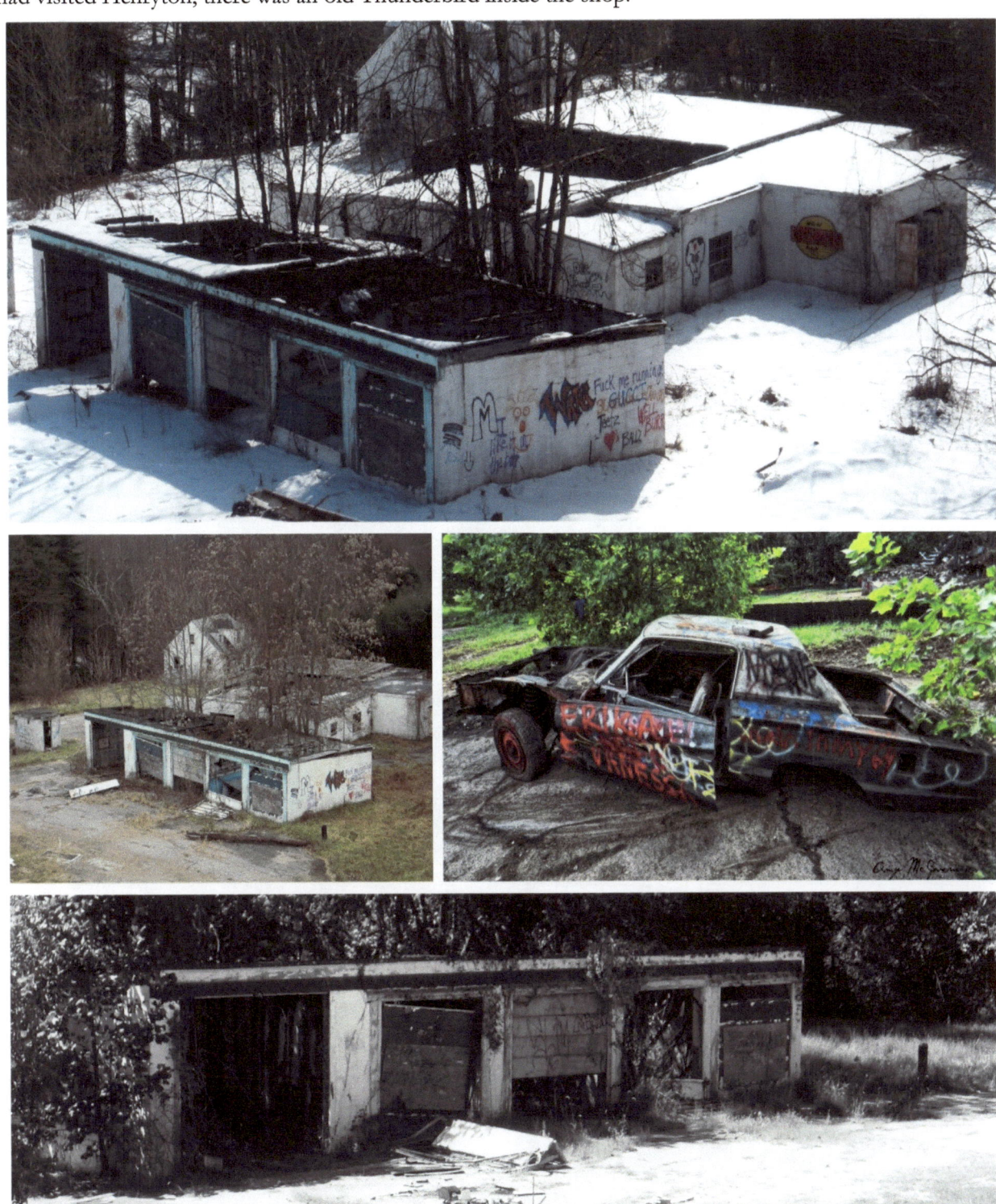

Nurses Cottage

The Nurses Cottage had a large back porch that faced the woods. Originally, it had two staircases, which were removed in the 60's during a renovation and fire escapes were placed on the outside. As the name states, it housed nursing staff.

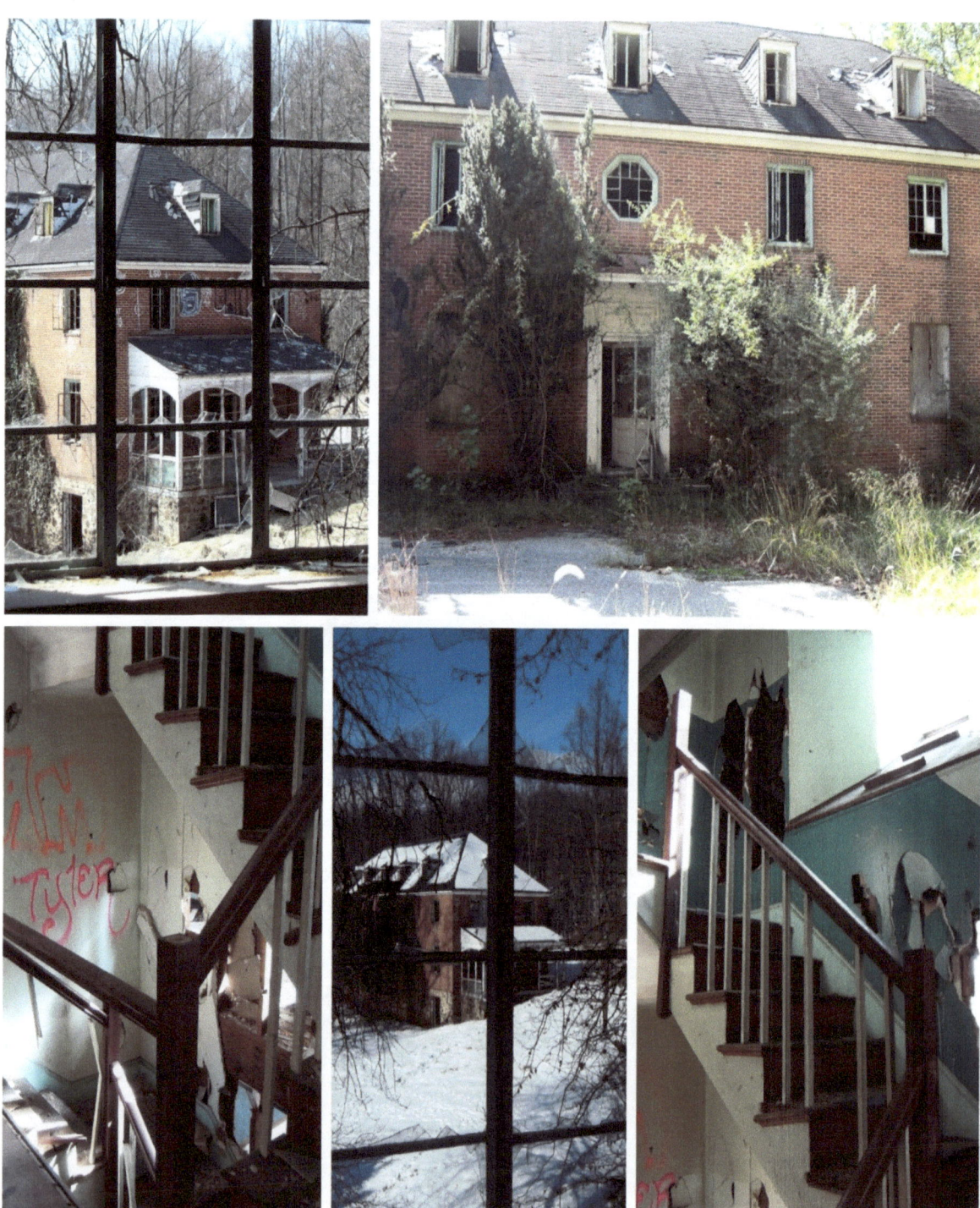

Pool

It is strange and rare to find a large pool at a hospital like Henryton. There is no information about it.

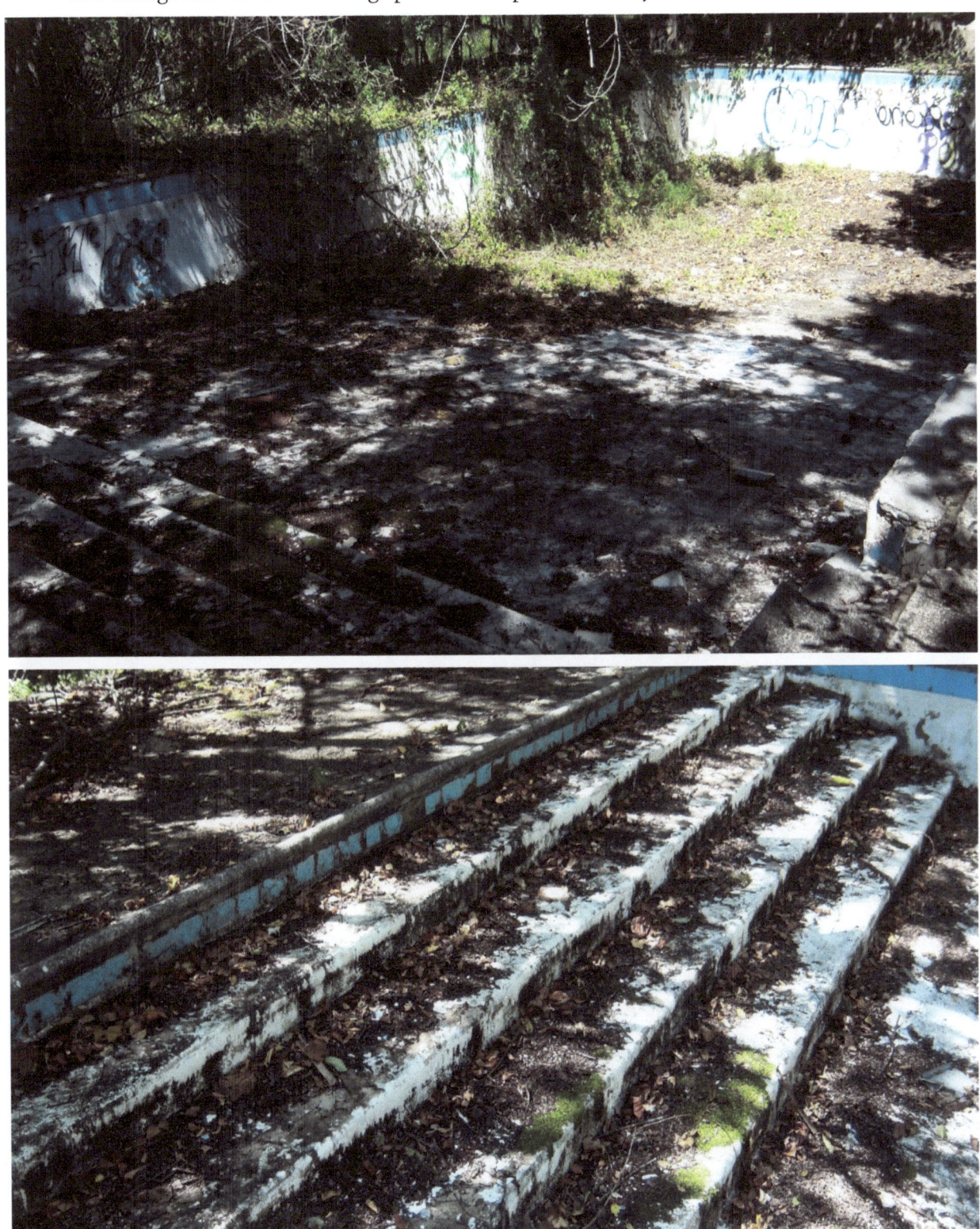

The Hog House

The hog house had a fire and was leveled before we ever had a chance to photograph it. I found Rick Cannedy's pictures on Flickr ©, taken in 2008. My very first contact in urban exploring was Rick and we met at Henryton.

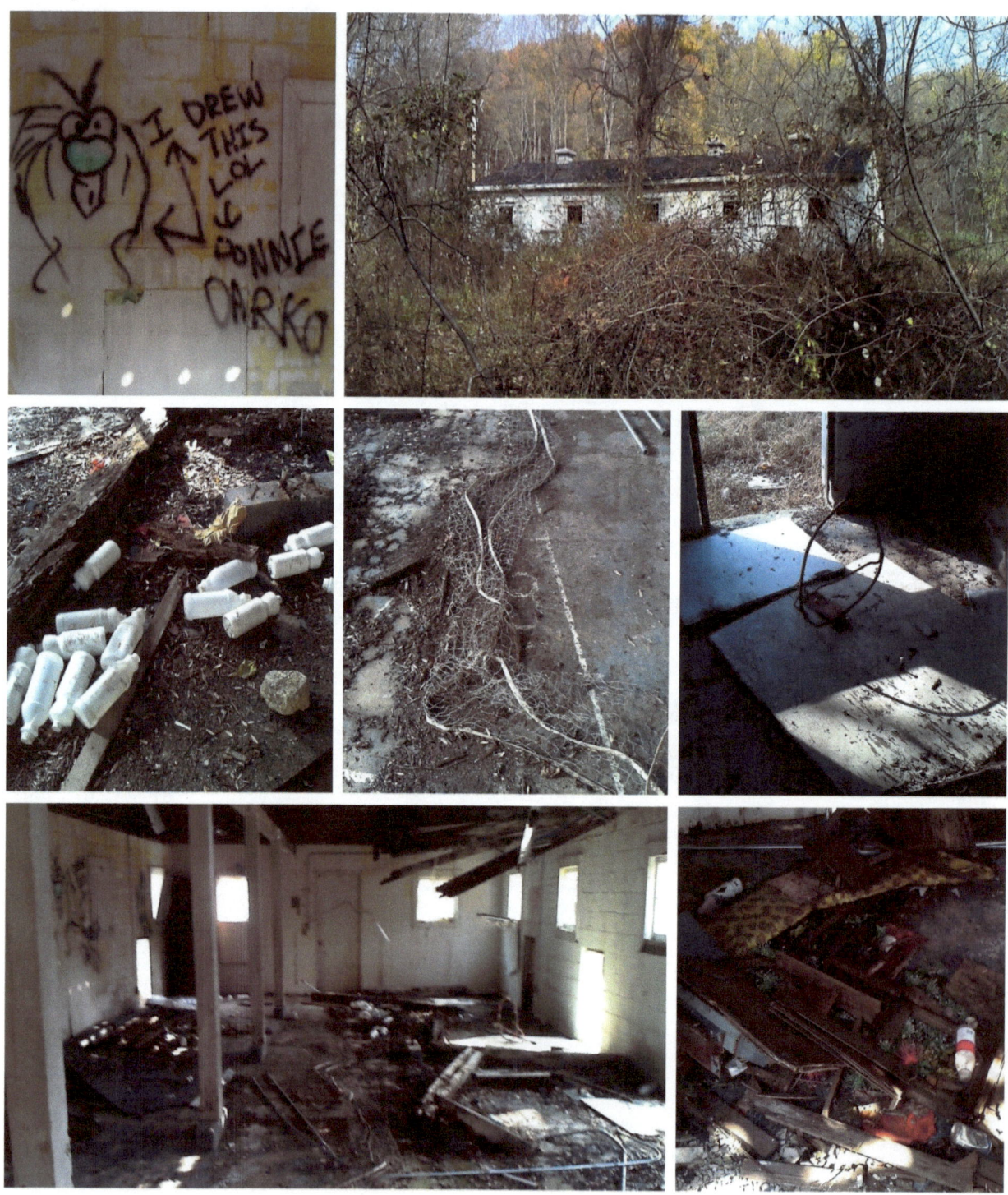

CHAPTER 3 DIARY HISTORY

This document came from The Gate House Museum in Sykesville, MD. It was written by an individual who resided at Henryton from 1919 until 1928. He states that he is a truck driver at Henryton that moves coal. Their name is unknown, but it is dated January 21, 1960, and the original document was written on a typewriter.

Henryton, MD

"In 1919 Henryton was just a whistle-stop on the main line of the Baltimore & Ohio Railroad. Henryton property consisted of eleven houses loosely scattered in the area. Only three of these houses were close to the railroad. Two of these houses were estimated within thirty feet of the track. The community of Henryton derived its name from Henry Devries, whom once owned vast tracts of land in this area on both sides of the Patapsco River. In the late 1800's, Henry Devries owned and operated a store that was located on the spot where the present greenhouse stands. This store burned down and was never rebuilt. Henryton did not again acquire a store and post office until 1920. Mr. Jesse Walter Porter, who, lived with his family in the larger of the two houses adjacent to the tracks, opened a store in front of the house, and shortly thereafter a post office was installed in part of the store. In 1921, Alexander Le Rendu, who lived in the smaller house next door, bought out the stock in Mr. Porter's store. Mr. Porter and his family moved to a little farm up along the Patapsco River. In 1922 the state bought the farm of George Holman and began erecting a hospital for tubercular patients. By early 1924 the hospital was completed, staffed, and was taking in patients.

This greatly assisted the economy of the area. The major industry in this area, during the 20's, and before, was the quarrying of feldspar, flint, and soapstone. Also, a great deal of pulp wood, for the processing of steel, and for making paper, was shipped from Henryton. By the time the hospital was in operation, a hard surface road had been built from Henryton out to what is now Route 32. Previous to this there were no hard surface roads closer than six miles to Henryton. With the advent of the hospital and hard surface road, the store and the post office at Henryton thrived. In 1928 the State acquired the property that the store and post office were located on, Alexander Le Rendu was forced to move his business to Westminster, MD. The post office was transferred from the store to the hospital. During the above mentioned years, Henryton was served by eight passenger trains a day, four of which carried mail. There were two trains East at 6 and 7 and two at 3 and 5. Westbound trains were at 9AM and 2:30 and 6 and 8PM. Westbound trains were at 9AM and 2:30, 6 and 8PM. Late on, as more and more people turned to automobile transport, this rail passenger service was reduced and finally curtailed entirely. With the passing of the years, the hospital at Henryton was underwent several changes. Today, instead of serving the needs of tubercular patients, it serves the needs of mental patients. Through the years, the hospital was greatly expanded from its original size. The area where the boiler house, greenhouse, and several other buildings now stand was once called "Tie Yard" were railroad crossties and telegraph poles were stored in massive piles. This was during an era when Henryton could boast of two railroad tracks running through it and also a sidetrack capable of accommodating 6 or 8 cars. At the northern end of the boiler house area, there was once a spring of cold, crystal clear, pure water. This spring now lies beneath approximately 10 feet of fill dirt. Since 1928 the state has acquired vast parcels of land on both sides of the Patapsco River, This land has been converted from taxable farm land into non-

developed park land. The 3 houses which stood close to the tracks at Henryton, and various other houses that stood on state acquired property have now been destroyed.

Today, Henryton presents a desolate view in comparison to the view it presented in the mid-twenties. Nature is now slowly, but surely reclaiming the cleared areas that once provided comfortable homes for those who lived there during those halcyon days.

During the 20's several individuals in the vicinity of Henryton made a comfortable living through seasonal trapping. At that time there was an abundance of game, such as, muskrat, raccoon, possum, groundhogs, fox, mink, and rabbit. Muskrat, raccoon, and fox pellets brought a substantial price in those days.

The advent of motor travel and truck transport had a devastating effect on rail transport, and this has caused small communities like Henryton to wither, and die and go out of existence in the Patapsco Valley. A striking example of this is the now extinct village of Daniels, once known as Alberton, and the village of Oella which is near extinction.

Actually, Henryton now exists only as a name on the map of Carroll County. The only reason for its existence, as a name, is the fact that a state operated hospital is located there. The last industry, to exist as such, was Ourslers's soapstone quarry, just west of Henryton. The industry is now defunct and its equipment lies in rusted extinction.

It would be difficult for today's generation to visualize the methods used in constructing the hospital at Henryton. The materials that went into the construction of the hospital, such as , sand, gravel, cement, and reinforcing steel, was transported to the site by horse drawn vehicles. Instead of truckers in those days, there were "teamsters". These teamsters contracted to haul materials with their horse drawn conveyances, in the same manner as trucker's today contract to haul materials.

The steel plates that were used to construct the huge water tank on the hill above the hospital were all transported to the site by horse drawn conveyances.

When the hospital was first constructed, the boilers were in a basement section of the hospital building designed for that purpose, and was called the boiler room. The boilers were then fired by coal. The coal was delivered by rail to the sidetrack at Henryton. A hard surfaced road had been built from the railroad crossing to within yards of the hospital's front entrance. The first coal delivered to the hospital was by chain-driven model T Ford truck of approximately one and a half ton capacity. With the carload of coal on the siding, the doors of the bottom pockets would be opened and all the coal would drop out on the ground. It then had to be shoveled into the truck until the truck was loaded. Then upon arriving at the boiler room, the coal had to be shoveled from the truck, through a window opening into a bin in the boiler room. It required several days to transport a carload of coal from the siding to the hospital. The roadway from the hard surfaced section around the back of the hospital where the boiler room was located was a dirt road, and in bad weather, the truck frequently got stuck in the mud and had to be dug out. This writer, having been the operator of that truck, can speak with authority on that subject. Hauling coal in those days was indeed a grueling task.

After the hospital was in operation, the rail traffic increased as more and more people came to visit friends, and relatives confined in the hospital. Although the B&O railroad did erect a waiting room

for passengers, in inclement weather, the railroad never did operate a regular station at Henryton where you could purchase a ticket. The closest ticket office was at Sykesville, 4 miles west of Henryton. During the 20's, the fare from Baltimore to Henryton was 98 cents. The fare from Henryton to Sykesville was 10 cents.

Before the hospital was built, the passenger trains did not stop at Henryton unless there was someone on the train who wanted to get off there, or the engineer saw someone waiting on the platform at the crossing. When the trains went through without stopping, they picked up the mail on the fly. There was a mail rack erected on both east bound and west bound tracks. The mail sack was affixed to the rack by steel rings in each end of the sacks. The center of the sack was drawn tightly together with a strap. As the train approached the rack, the mail clerk in the mail car raised a hook-like device with extended out from the side of the car and snatched the mail sacks into the car. The mail for the post office was simply tossed off the train by the mail clerk, and the postmaster picked up the sack from wherever it had fallen.

These mail racks were, in fact, a hazard to an engineer, and were taken down in the mid-thirties. When the rack was not operating properly, sometimes the arms did not fold back when the mail sack was jerked from them. On several occasions these extended arms struck an unsuspecting engineer on the head and inflicted painful injuries.

Unimportant as Henryton may be, it does have a unique distinction of being the scene of a murder that has remained unsolved for 63 years thus far. *The End*

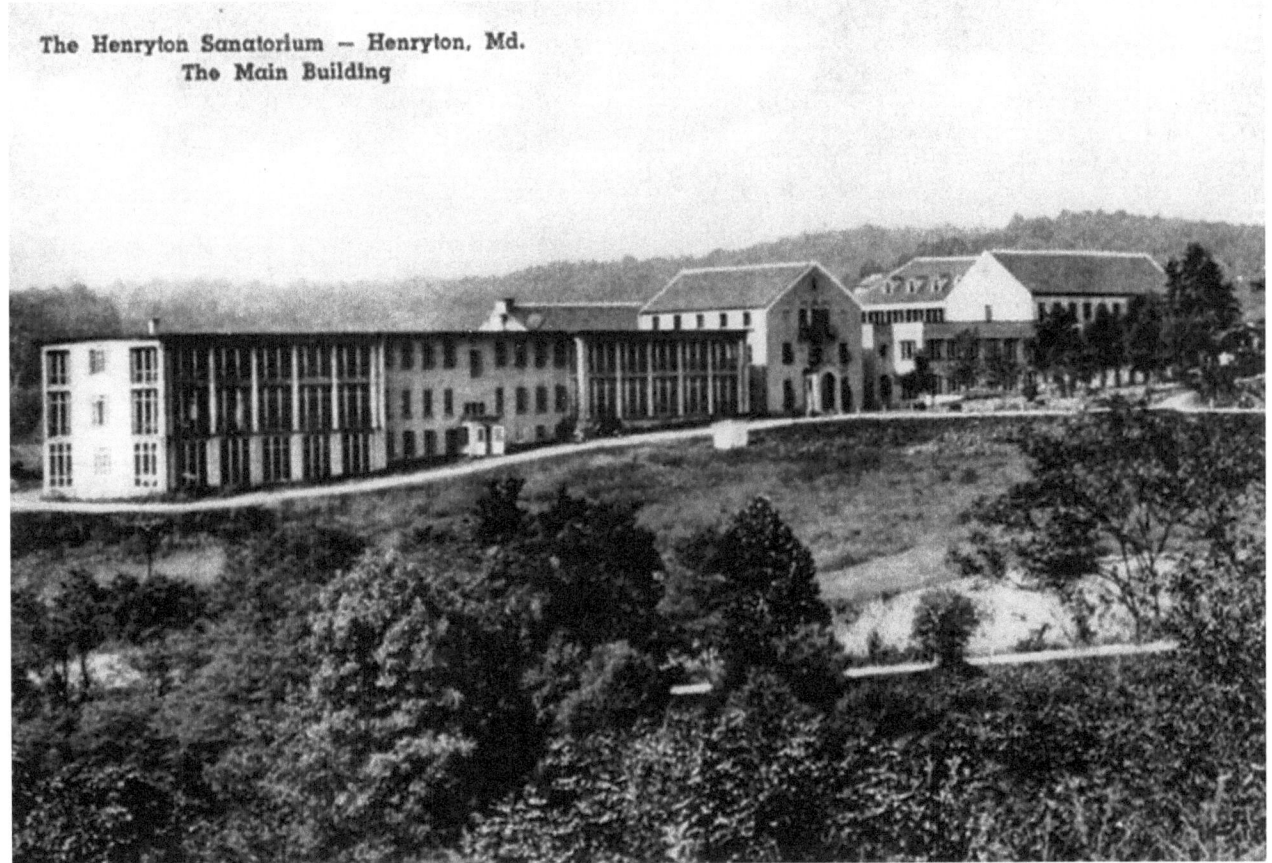

The Henryton Sanatorium — Henryton, Md.
The Main Building

CHAPTER 4 MYSTERIES: BEFORE THE DEMOLITION

This postcard was run in the Carroll County Times. I asked for the original owner and it is unknown. It has been posted all over the internet.

"During May of 2013, the State of Maryland site supervisors of the Henryton Project demolition were surveying the buildings before they were to be destroyed when they were approached by an elderly man, his face wrinkled from years of stress, and also held the aurora of a war veteran. He told the supervisors that the nurse's cottage, on the outskirts of the Henryton property, contained a claymore mine. Completely baffled, the supervisors followed the elderly fellow to the building and inspected the small, square object. It had the look, feel, and touch of an actual claymore. They promptly called the police and got in touch with the F.B.I., who came out to investigate. They scoured all of the buildings, high and low, looking for signs of any other detonate-able material. Once they managed to get back around to the building which contained the claymore, it had disappeared, along with the old man. To their surprise, no other workers had come in contact with the man, proving there to be no witnesses of his presence. He was never located, along with the mine. This left quite a scare on the hands of administrators of the Henryton Project, fearing that other strange things would be uncovered throughout the site's demolition."

[The M18A1 Claymore is a directional anti-personnel mine used by the U.S. military. Unlike a conventional land mine, the Claymore is command-detonated and directional, meaning it is fired by remote-control and shoots a pattern of metal balls into the kill zone like a shotgun. The Claymore fires steel balls, out to about 100 m within a 60° arc in front of the device. It is used primarily in ambushes and as an anti-infiltration device against the enemy.]

The Henryton Project required twenty-four hour security, including 8 foot chain-link fences, a constant security patrol, and flood lights. Miraculously, on a rainy June 19, 2013 night, a group of local high school kids were lurking around in the darkness, expecting to gain the entire Henryton experience. It is not unlikely to see groups of teens roaming the grounds at night, as it is practically considered a right-of-passage in the Carroll County area. One particular gaggle of teens managed to scare their young friend to the point of hysterics, causing her to jump through a window with jagged glass, and whilst wearing improper shoes, cut her feet. She sprinted through the building, leaving bloody foot prints upon the floor. In the early morning rain, workers of the Henryton Project found pools of blood (rain water mixed with the foot prints). The teens were never identified. Here is a shot of the window and the bloody footprints left behind.

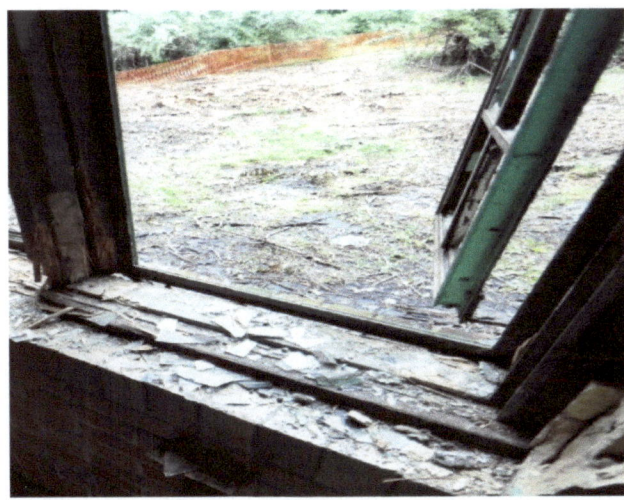
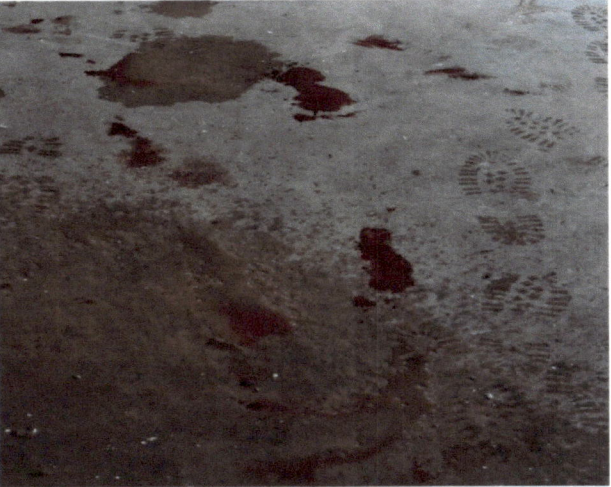

There have been many curious kids and adults who have wandered through Henryton to see the demolition, or catch a last glimpse of the place. On one particular day, there were fifteen teenagers. Every time the workers would confront them, they would all run down to the rail road tracks and break through the fence. No one caught them. I have seen on various internet boards where explorers have posted photos of the site when it was empty on a Sunday. Everyone wants that final shot of Henryton. No horse riders, making their way through Patapsco State Park, had ridden on the trails nearby when the demolition had started. In my sixty plus trips to Henryton, we always saw horseback riders wander through. I always was curious why they would bring their beloved beasts through a place with metal and glass on the ground. I asked my daughter, Kassi, a horse-loving girl who had ridden since diapers and regularly trained horses, what she thought, and she shook her head as well.

Here are a couple of stories passed down from former patients and neighbors. There is no evidence that these are true, just stories.

Back in the 1940's, pollution was not an issue for hospitals. Henryton had their own power plant to burn their garbage but not their human waste. There were pipes that ran down the hill from Henryton into the Patapsco River. The liquid that flowed out of the pipes was discolored and no one knew exactly was it was. Locals would not swim or fish in the Patapsco River near Henryton. These pipes still exist today but are empty.

Legend says that the local farmers near Henryton would come over and take the young healthy African American children and make them work in the fields all day. There were no Child Labor laws back then, and the children were unpaid. The children's parents were too sick to stop this from happening.

In 2010, there was a dump located on the property. Even though the power plant burned the hospitals garbage, they still just threw some garbage over the hill. Small antique perfume bottles have been dug up. The State of Maryland has old sanborn fire insurance maps. These were precise hand drawn maps to help the fire department in case of a fire to locate buildings. Nowhere on the Henryton map was a dump ever drawn in. This must have been an illegal dump. The demolition workers also came across the dump. There was also a cage located on the property and rumors say they use to lock bad patients in this. It looks like a garbage cage to keep the cans in and animals out, not a torcher cage. It had a trash can inside it the first trip I ever took to Henryton in 2010.

CHAPTER 5 JOURNAL ENTIRES – THE DEMOLITION

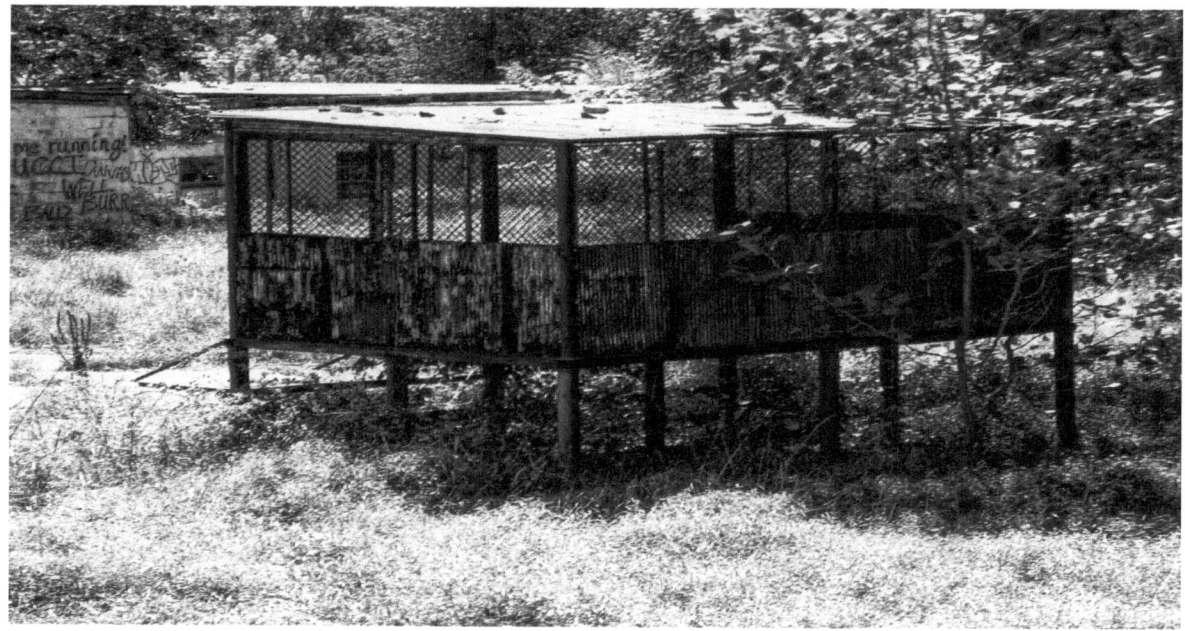

 June 12, 2013 was my first visit to Henryton while under the direction of Joe Nichols's team of demolition crewmen. We were guided around the property to observe and photograph the preparation. The Therapy Building, or Building 4, as they call it, was to be prepped for demolition that day. The windows were covered with plastic, making it impossible to peep inside. This building was considered "hazard waste", and would be torn down and disposed of within a hazard waste site. There were four in total that would be treated in this manner. The entire job site was alive with many large trucks going in and out of Henryton. We parked outside the gate and walked in. We were asked by many trucks if they were in the correct location. There were no address or signs outside the main gate. One driver asked if the place was haunted, and we laughed. Mr. Nichols was stationed out of Springfield Hospital Center, a few short miles away and had never heard of Henryton. Tucked away in the rolling hills near the Howard County Line, it was a forgotten place by the State of Maryland. He was amazed at all the buildings that existed. He offered to take us through the construction site, which we had already walked hundreds of times before.

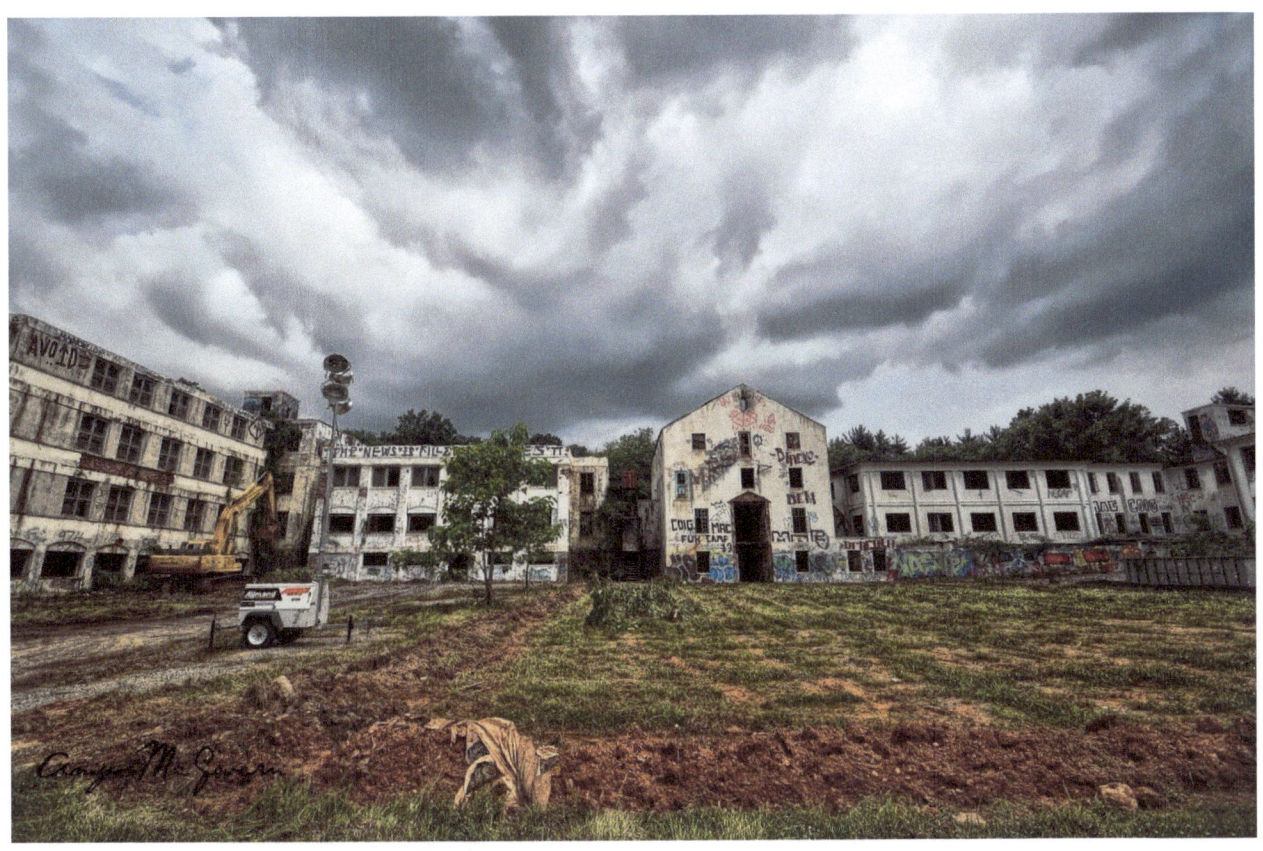

 We photographed all of the removal of vegetation in front of each building. The vines that were growing up the sides of the buildings were to be removed by heavy equipment. There was writing on the main building parking lot that was revealed after the weeds were removed, saying "Front-In Parking Only". The buildings were marked, and those that did not have an asbestos sign posted on them were alright to go into. Mr. Nichols offered to show us inside, but we declined. We had already seen what Mother Nature and vandals had already done to them. He was helpful in our quest to document the demolition of Henryton. Betty Fowler, a fellow photographer friend, and I made this trip.

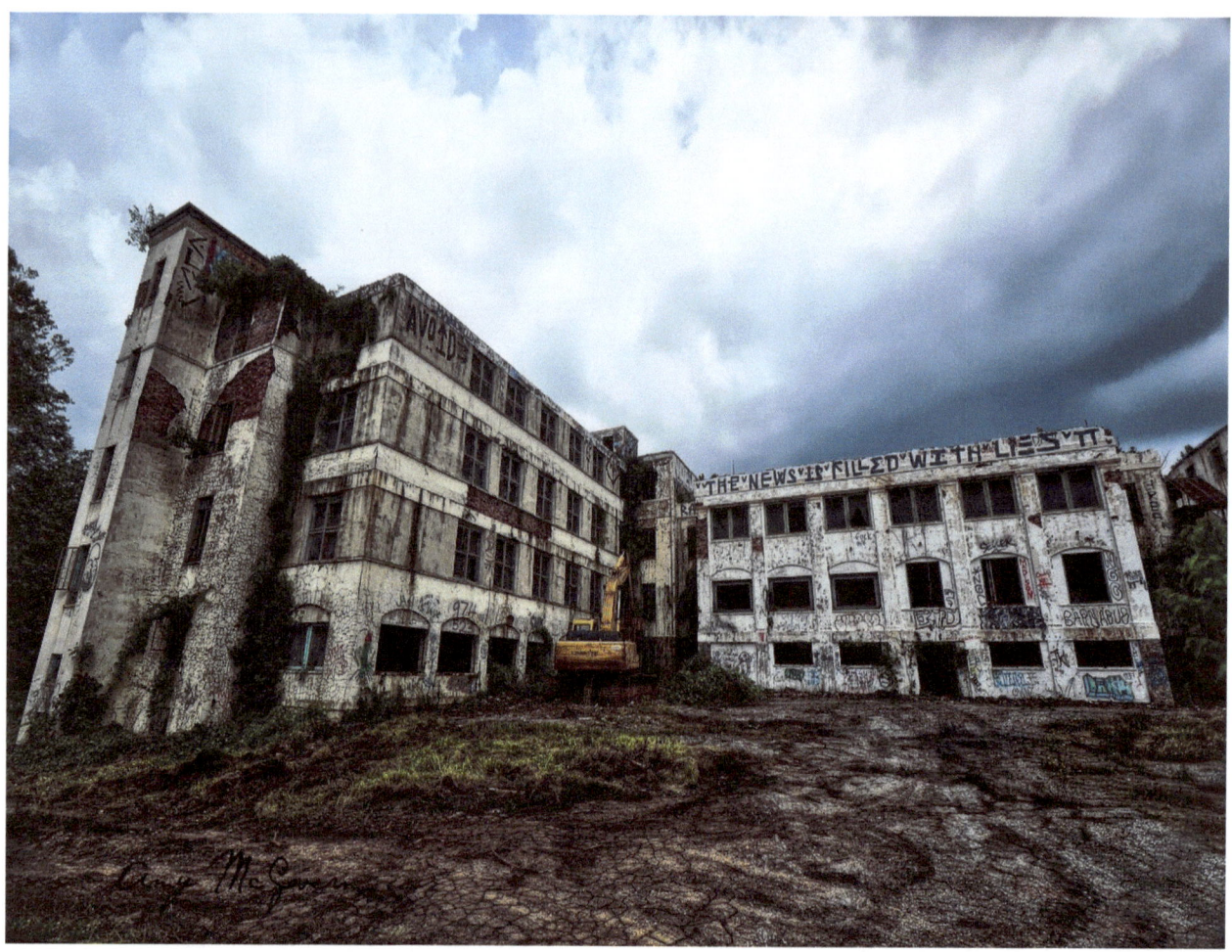

After about forty minutes of walking and taking photos, we had seen enough. It was a very hot and humid that day, and the hard hats we were required to wear, accompanied by safety vests and steel-toed boots, had taken its toll on out comfort level. We decided to return another day

On June 18, 2013, I received a call from Mr. Nichols in the late morning; he stated that the pool was removed the prior day. I really had no interest in viewing or recording it, since it was an unknown and unimportant structure to the Henryton site.

On June 19, 2013, we stopped by Henryton, and Tim and I went around with Mr. Nichols to see the construction site. This is when we discovered the bloody foot prints in the Therapy Building. Tim was amazed at how the landscape had changed so fast.

On June 26, 2013, was the first demolition. Betty Fowler, Tim McGovern, and I, along with Carroll County Times reporter Kelcie Pegher and her photographer attended the event. They started at 8:25 AM and it took over four hours to remove the middle of the main white building. They watered down the building the entire time to keep the asbestos from getting airborne. This building was the icon Henryton. The State wanted to make a road through it to make it easier for truck to navigate and removed the buildings.

Amy McGovern, Betty Fowler, Tim McGovern, Kelcie Pegher.

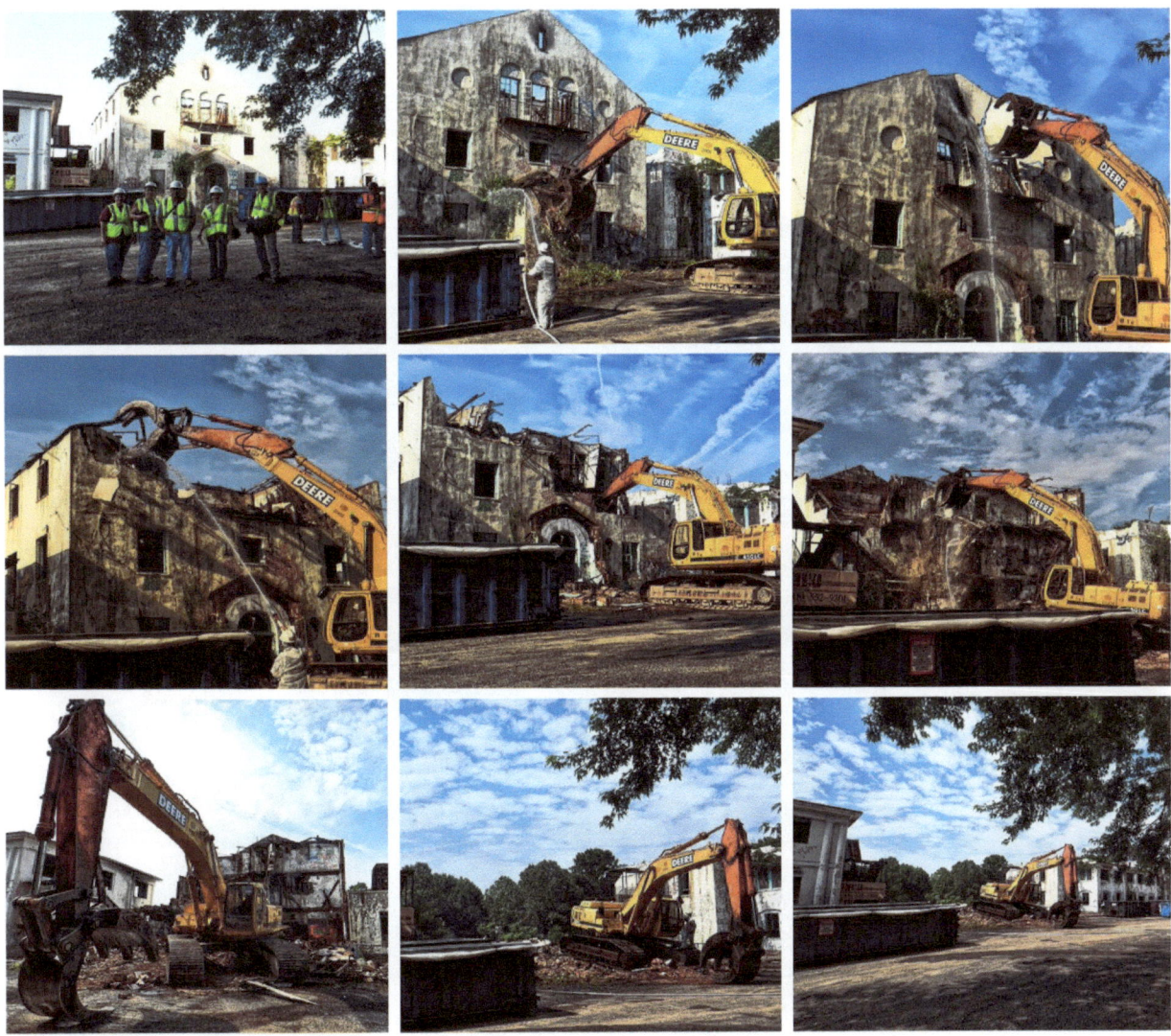

On June 27, 2013, Betty and I went to Henryton to check the worker's progress. They just happened to start demolition on the Nurses Cottage near the woods that day. It took a little over two hours. To our surprise, the Therapy Building and another smaller building that had no front were demoed that day.

Nurses Cottage Demolition

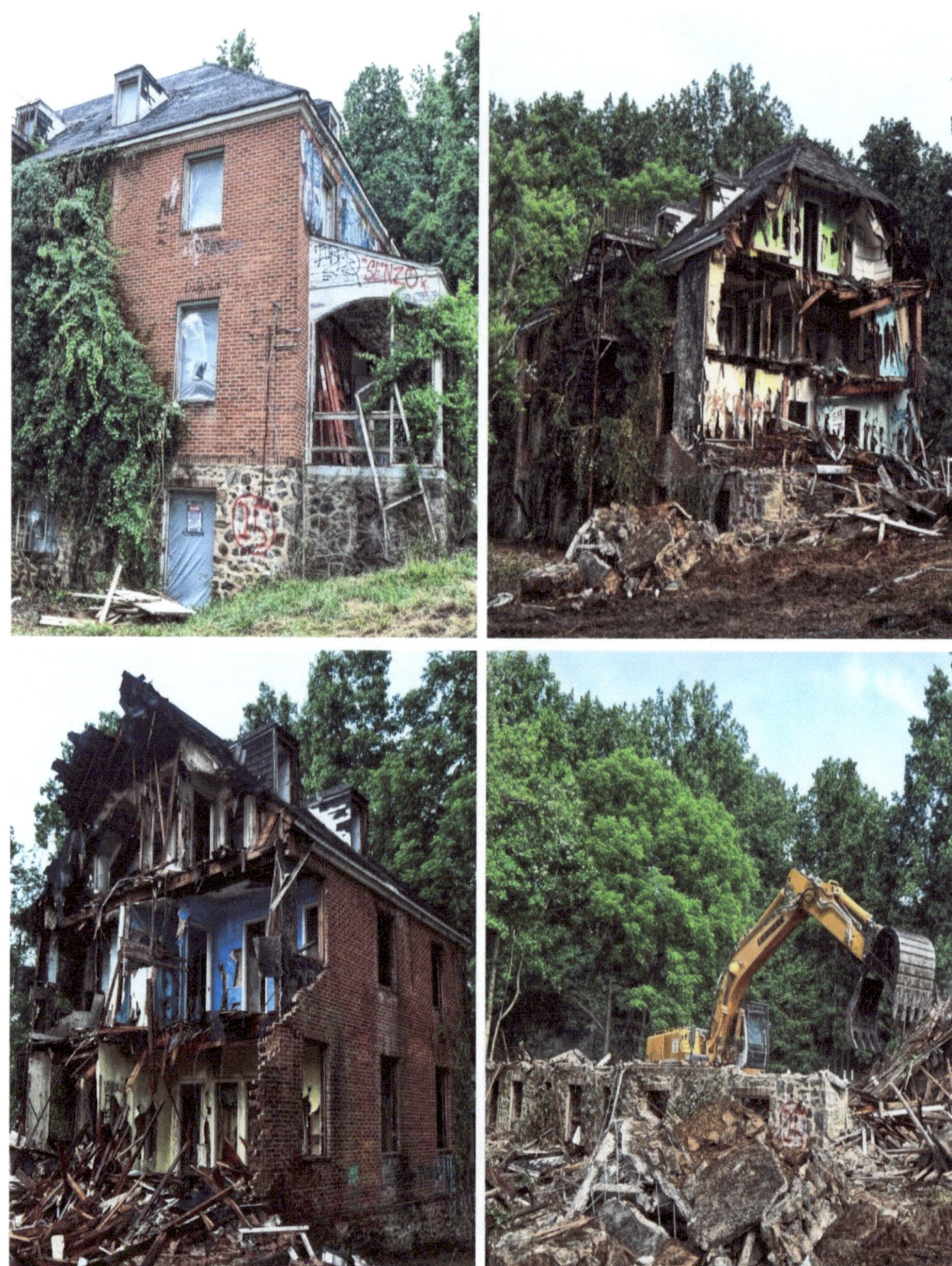

On July 9, 2013, Tim and I stopped by and just walked the perimeter and took photos.

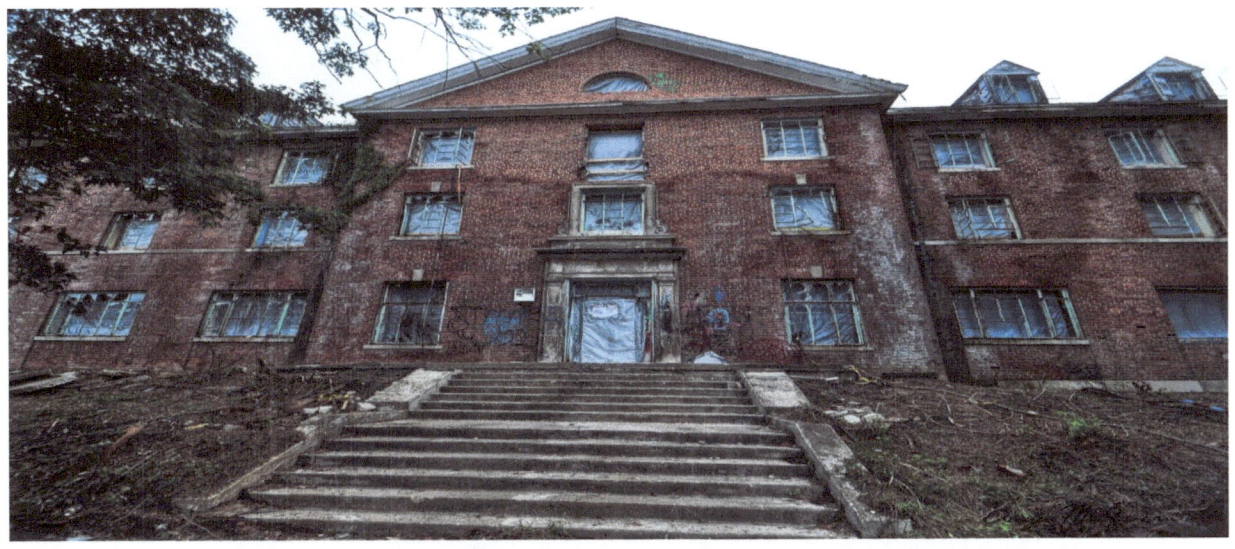

Here is a door the workers took the boards off of and it was still welded shut after all those years.

On July 11, 2013, since Betty had not been to the site in two weeks, she and I stopped by. The demolition on the Nurses/ Doctor's House began. This building was hit by lightning in April 28, 2011. We just happened to be there at the right time. It was rainy and humid, thank goodness we had umbrellas! I have great respect for the workers that do this every day! As we were leaving, the workers had a Bobcat machine and were using a chain to pull the metal windows out of the Administration Building in preparation to demo it the following week. Due to rain, it was delayed a few days.

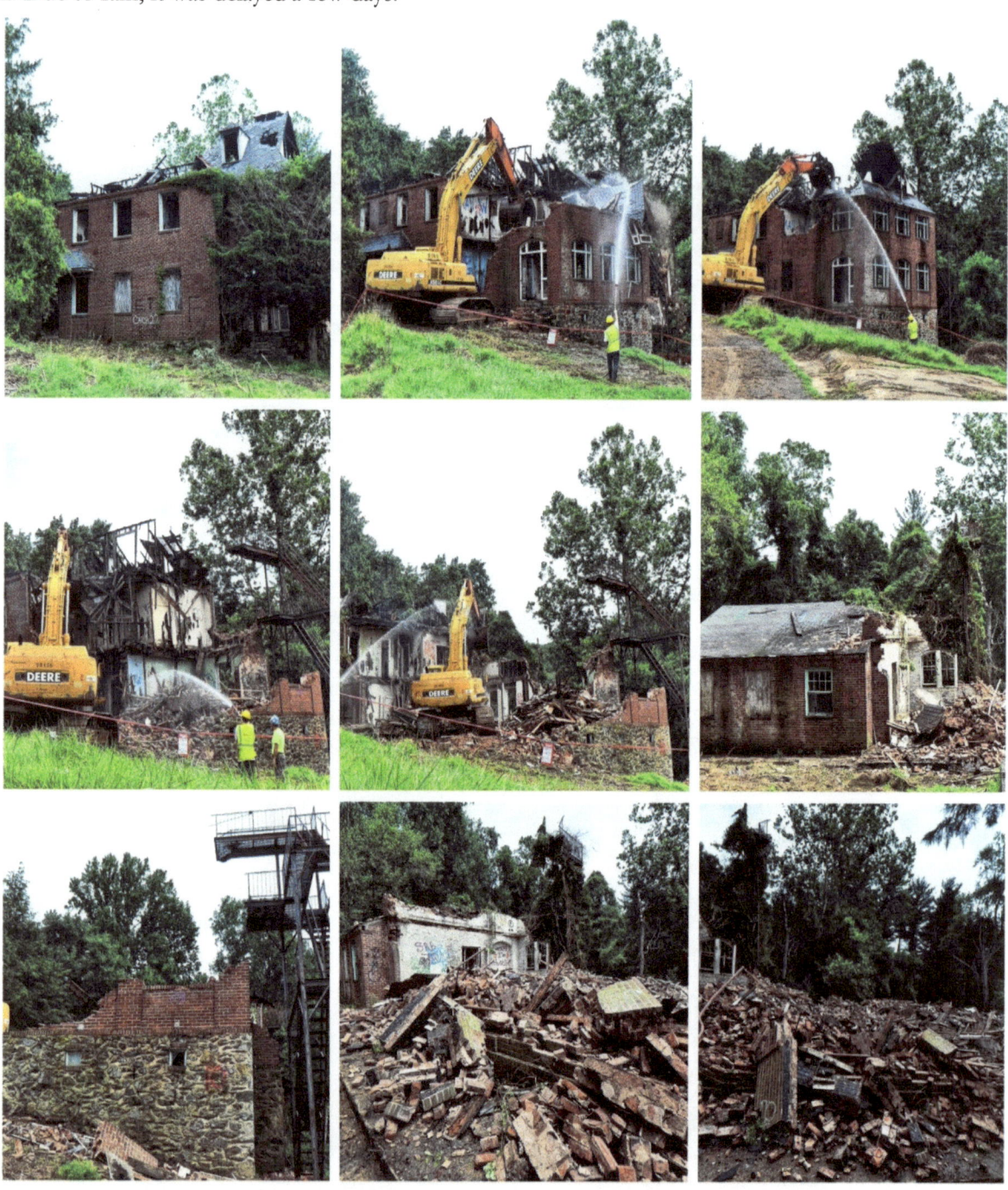

Preston Hare showed us a "Bunker" as the State of Maryland map had labeled it. After Betty researched, she found it was the remains of an old house.

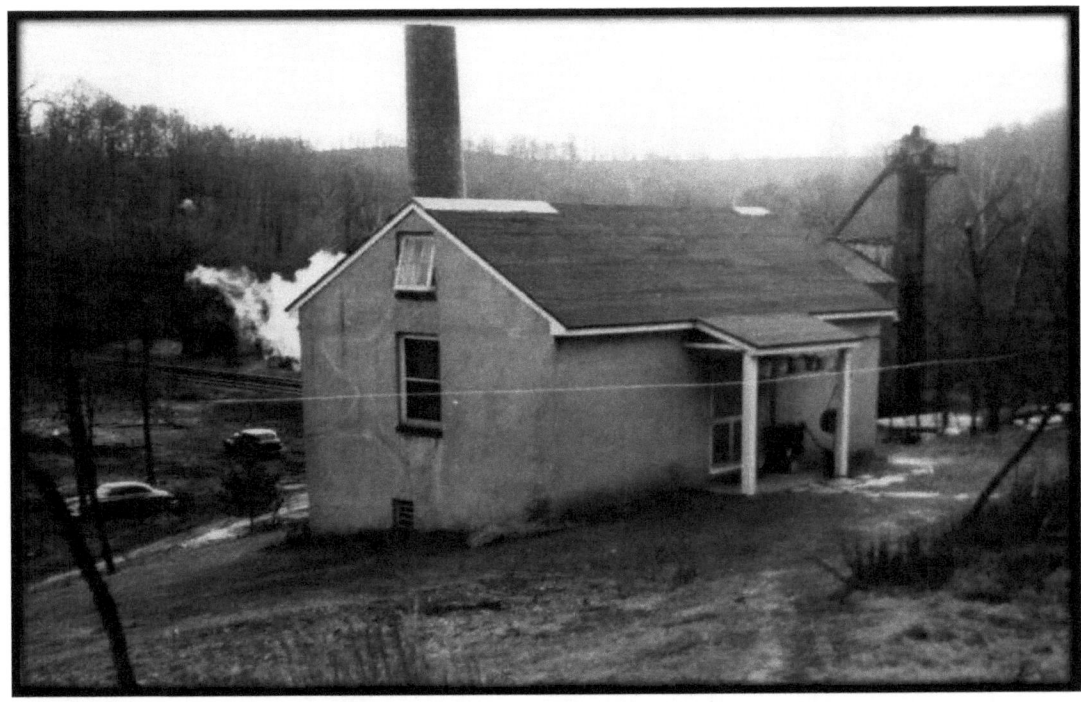

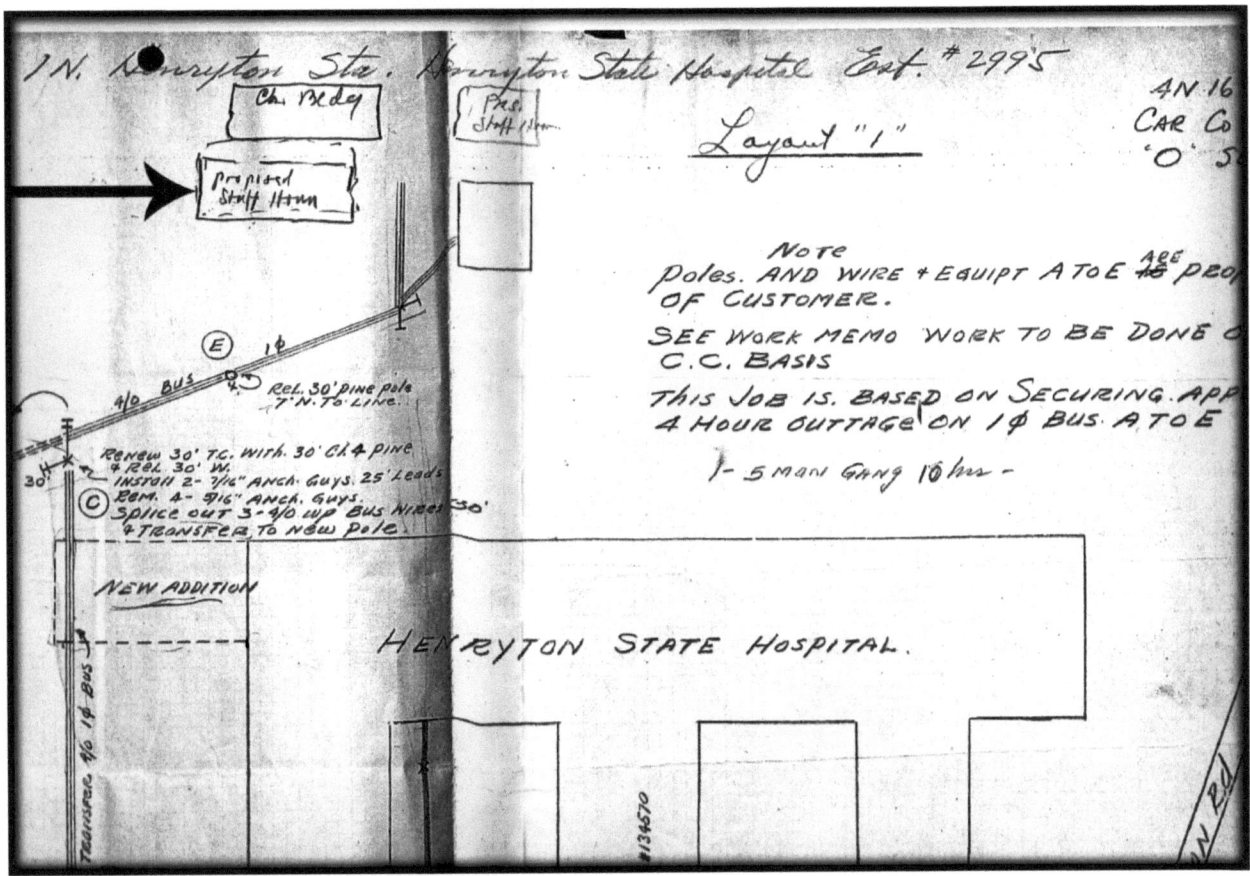

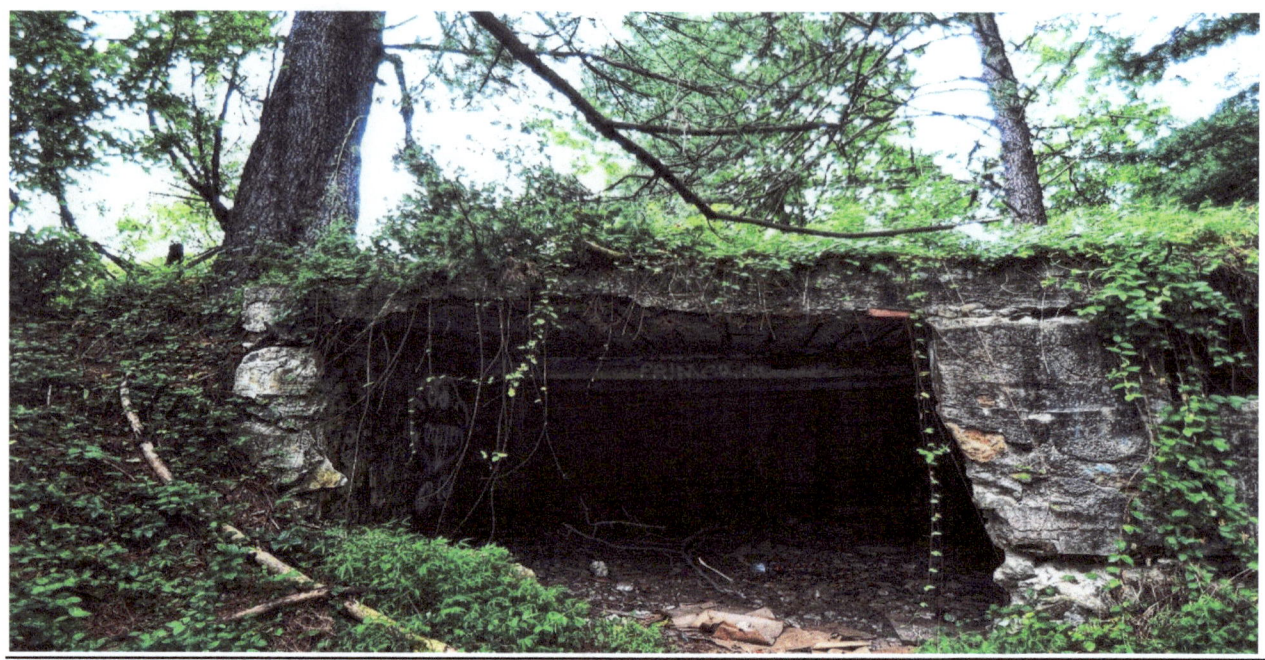

July 18, 2013, the Administration Building, or Building #3, was destroyed. It was the building that contained water between the walls one winter, which had shocked us with all the frozen iced walls. This shot is during the abatement process in July of 2013.

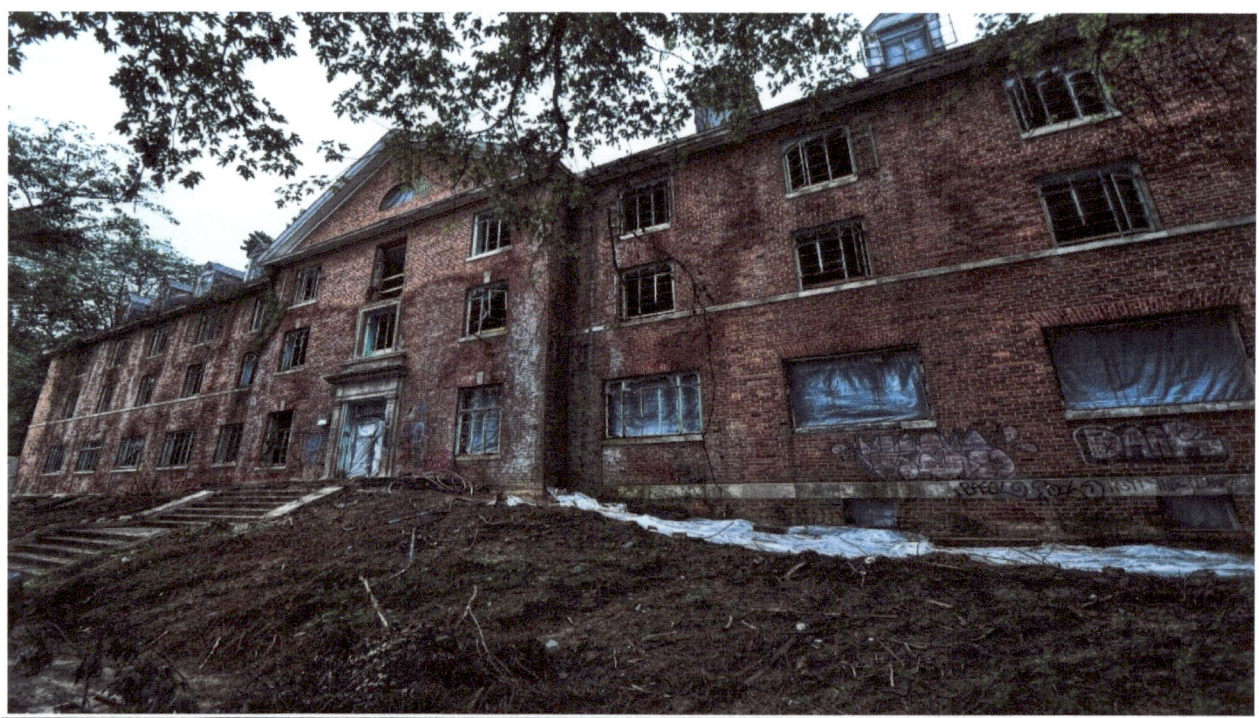

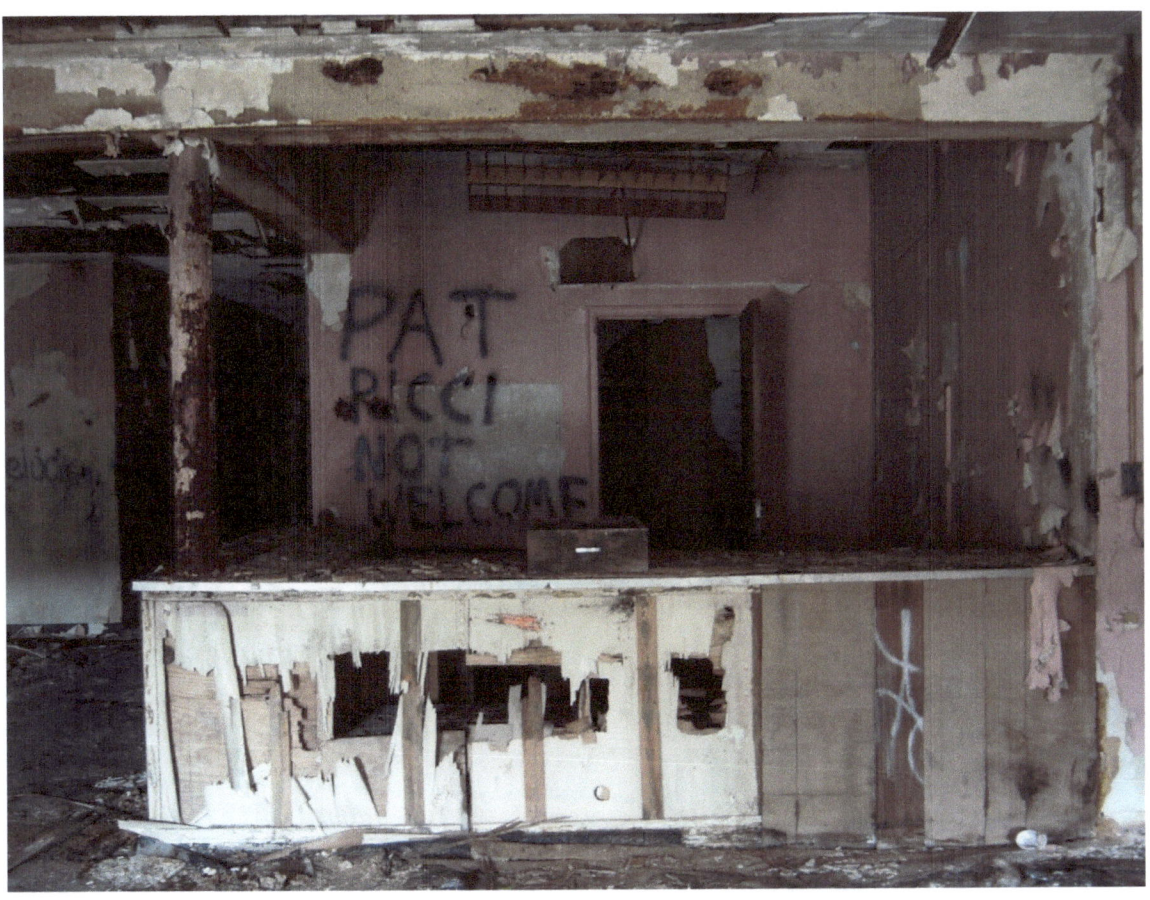

Reception Desk in the Administration Building entrance 2010.

Demolition of Nurses Home

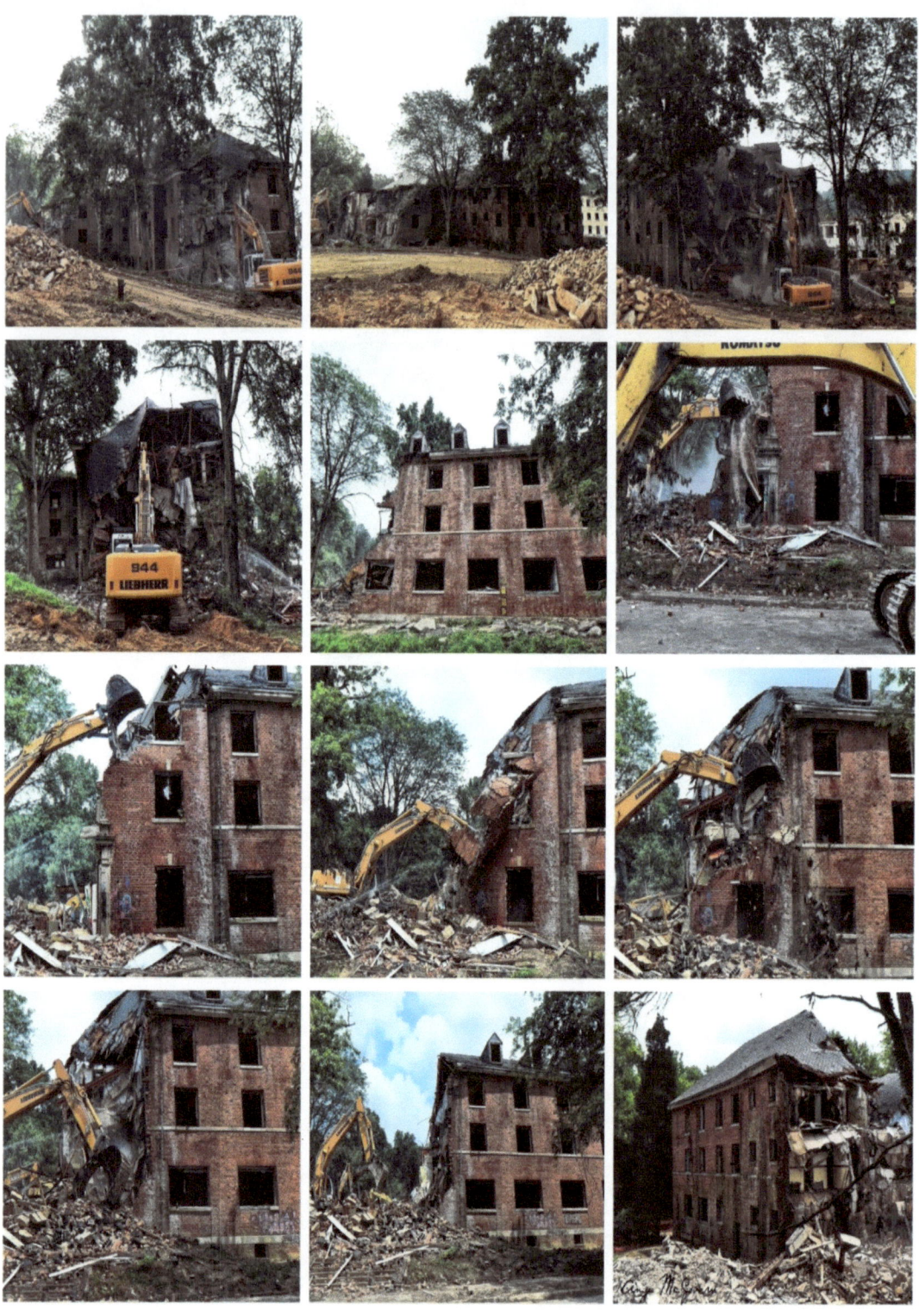

July 20, 2013 Tim McGovern and I went over to see how the demolition was progressing.

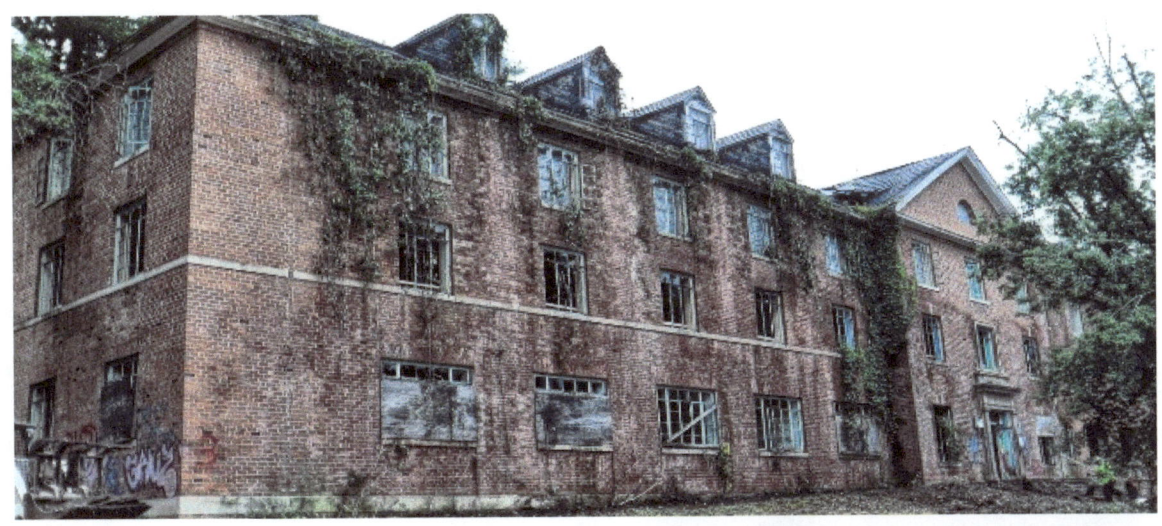

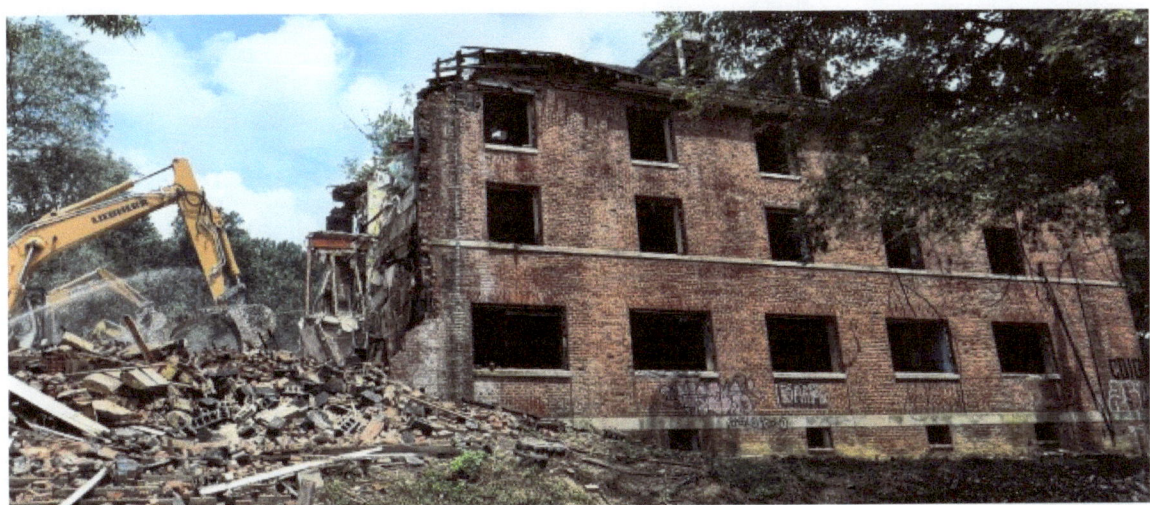

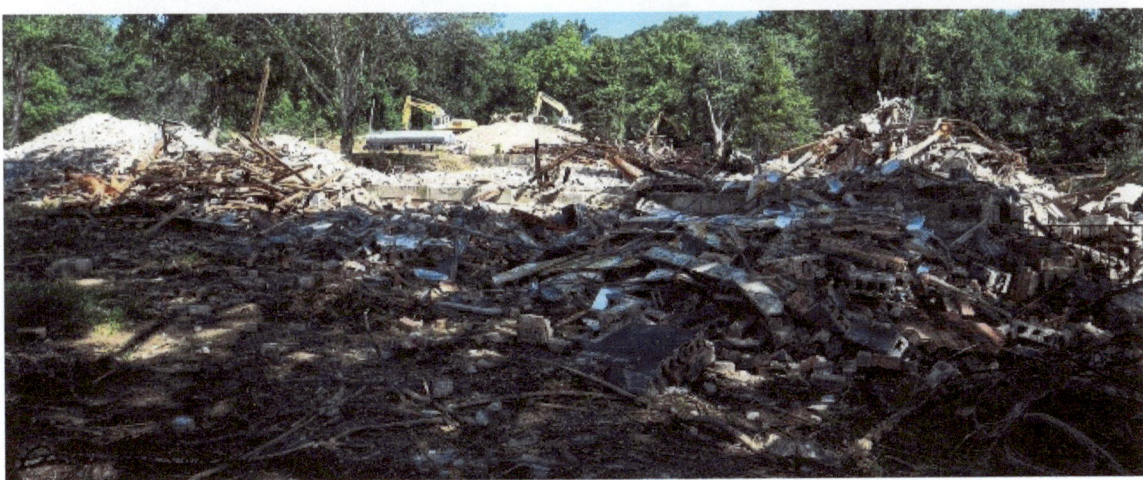

August 1, 2013 was demolition day for the Main East Wing. Preston Hare and Patrick Fink were in charge today. It started out at 7:00 AM with rain showers and Betty Fowler and I left at noon to high sun. This is the demo they completed in the first five hours.

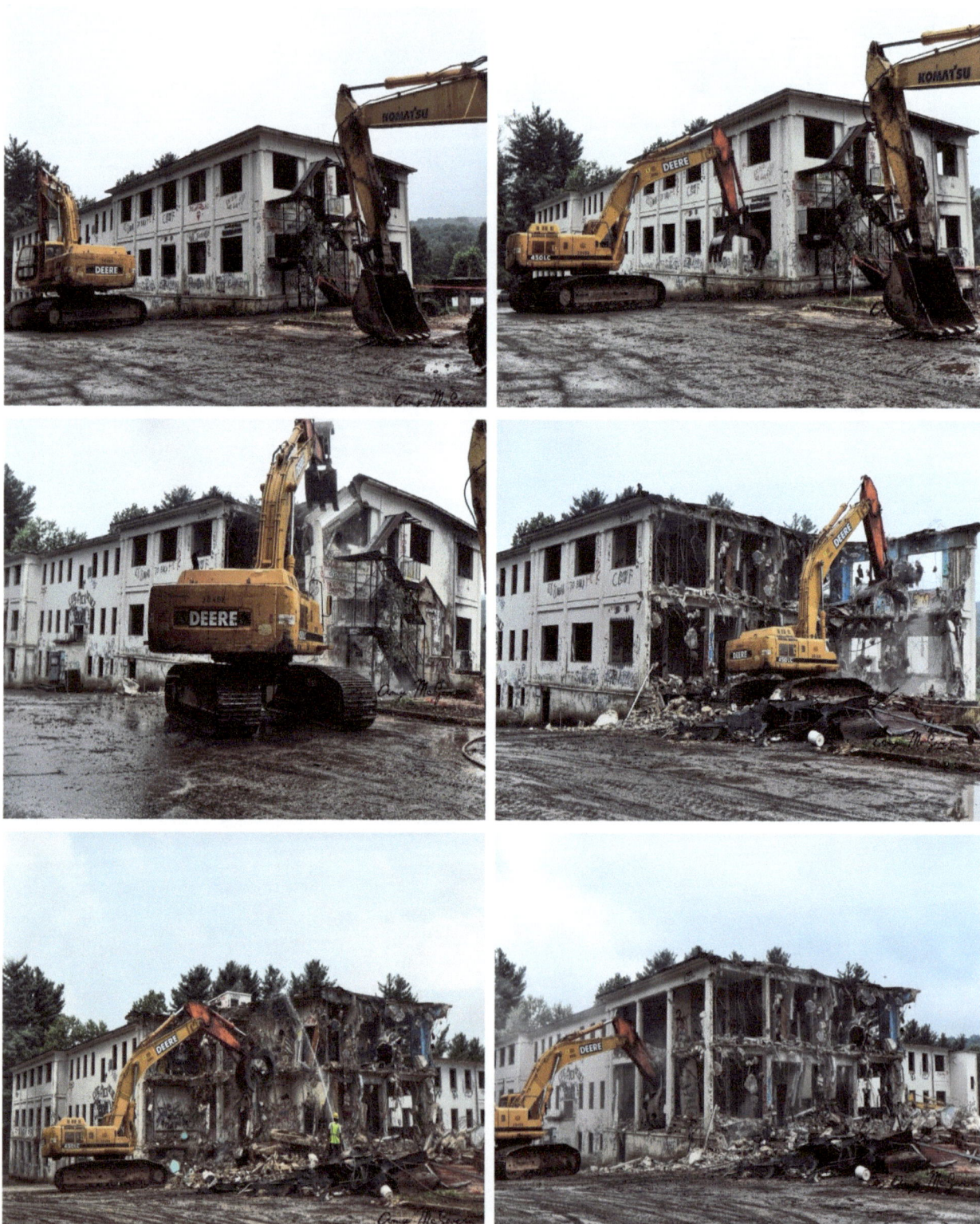

August 2, 2013 Tim McGovern and I stopped by to check on the progress of the demolition on the East Wing. No more buildings as you drive in.

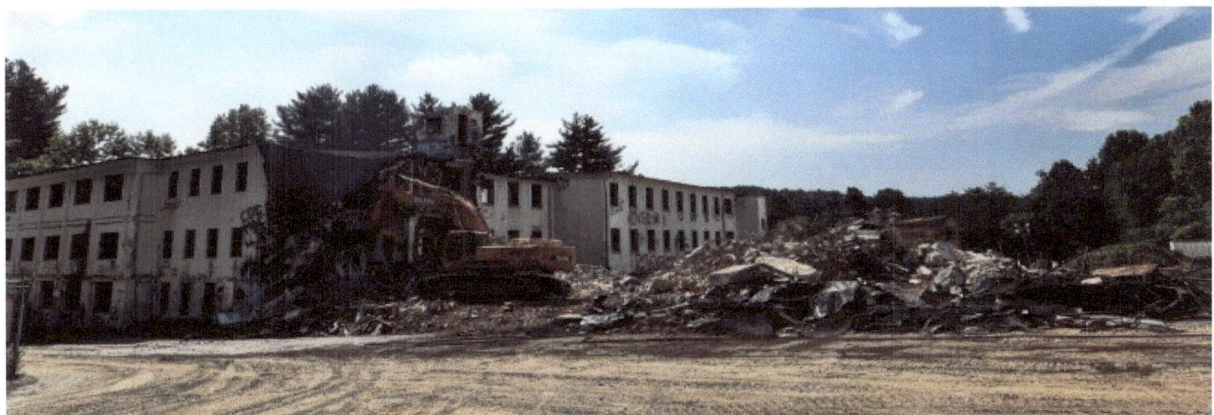

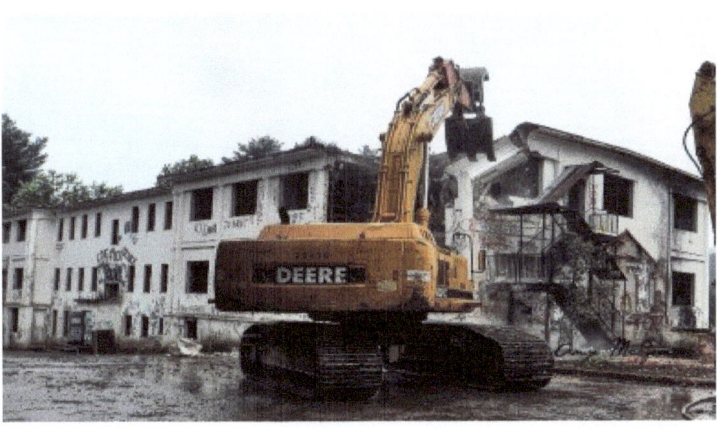

East Wing elevator demolition. 8-6-13

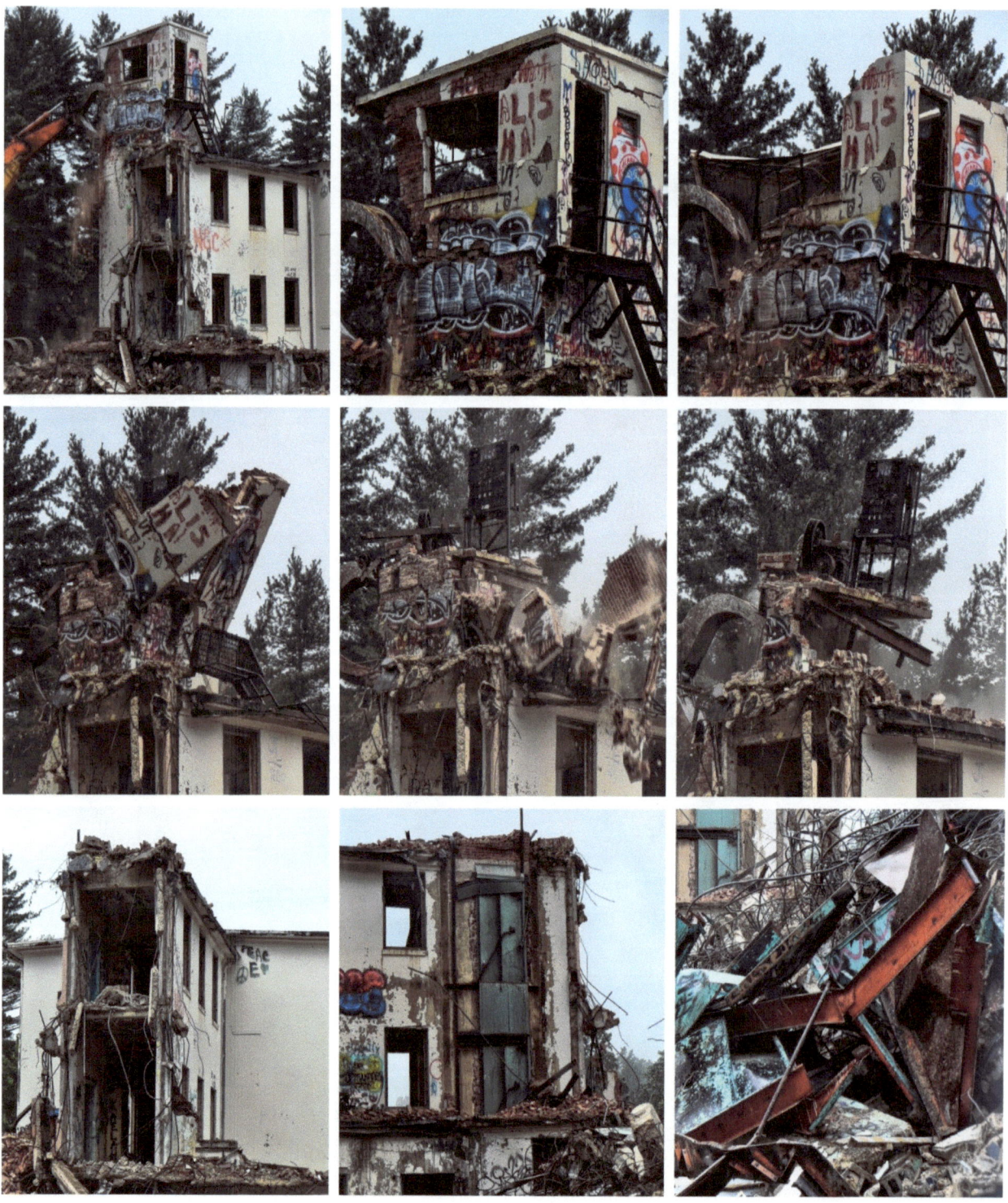

On August 20, 2013 the West Wing demolition was started. It will take them a week to complete this building with the elevator shaft.

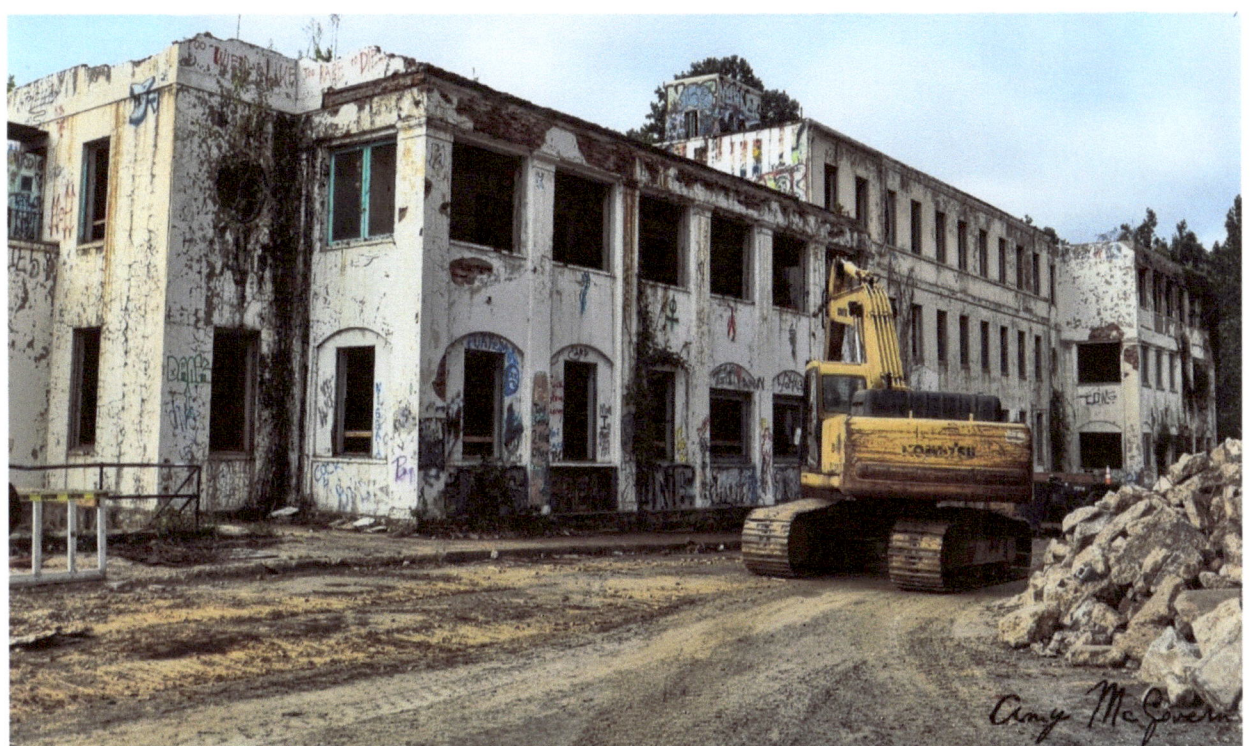

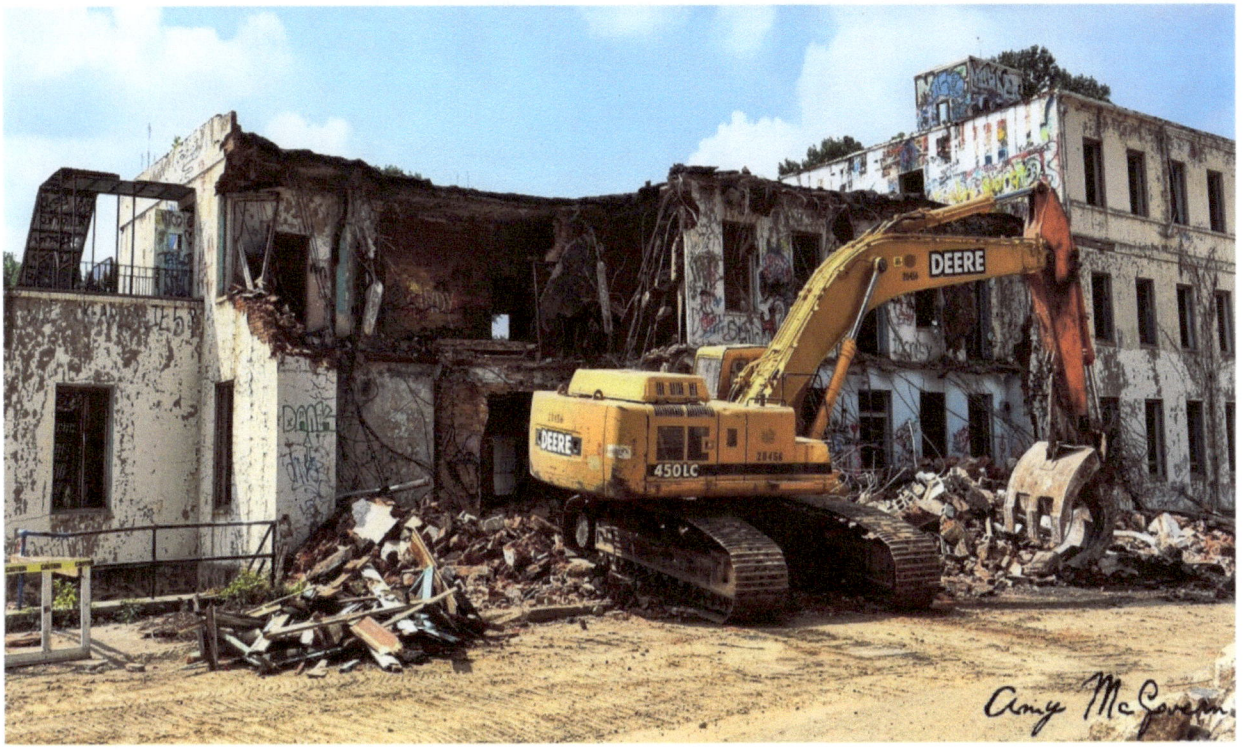

September 11, 2013 Here are a few Before and After shots

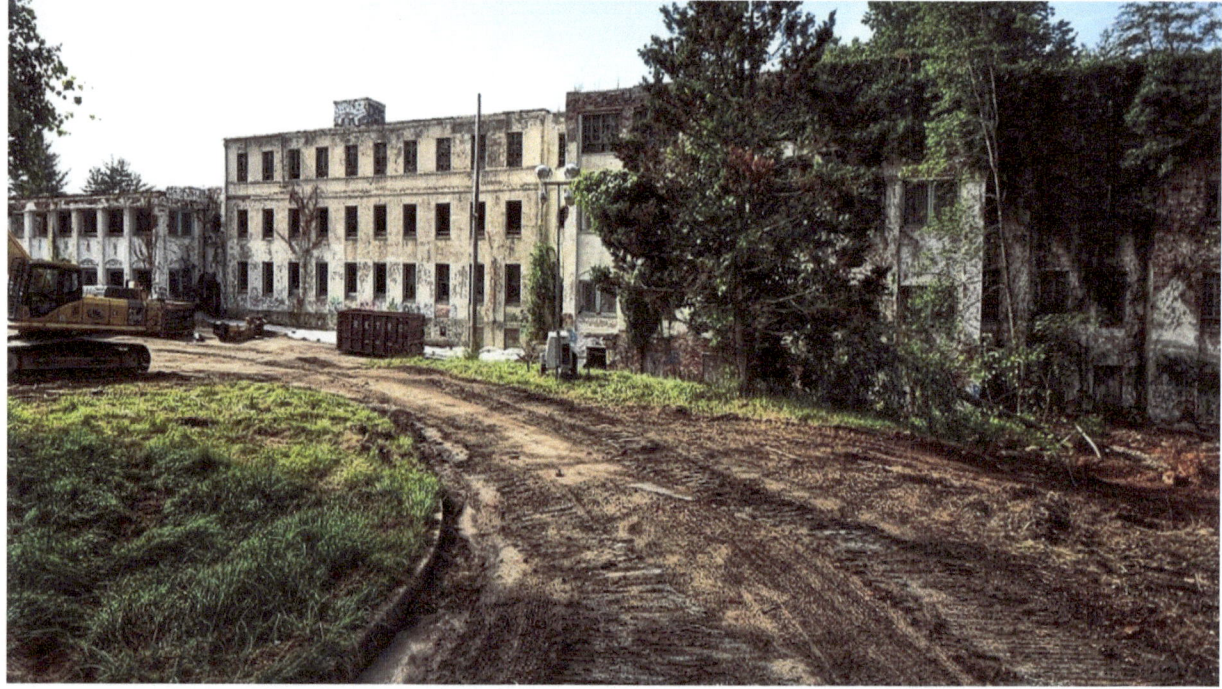

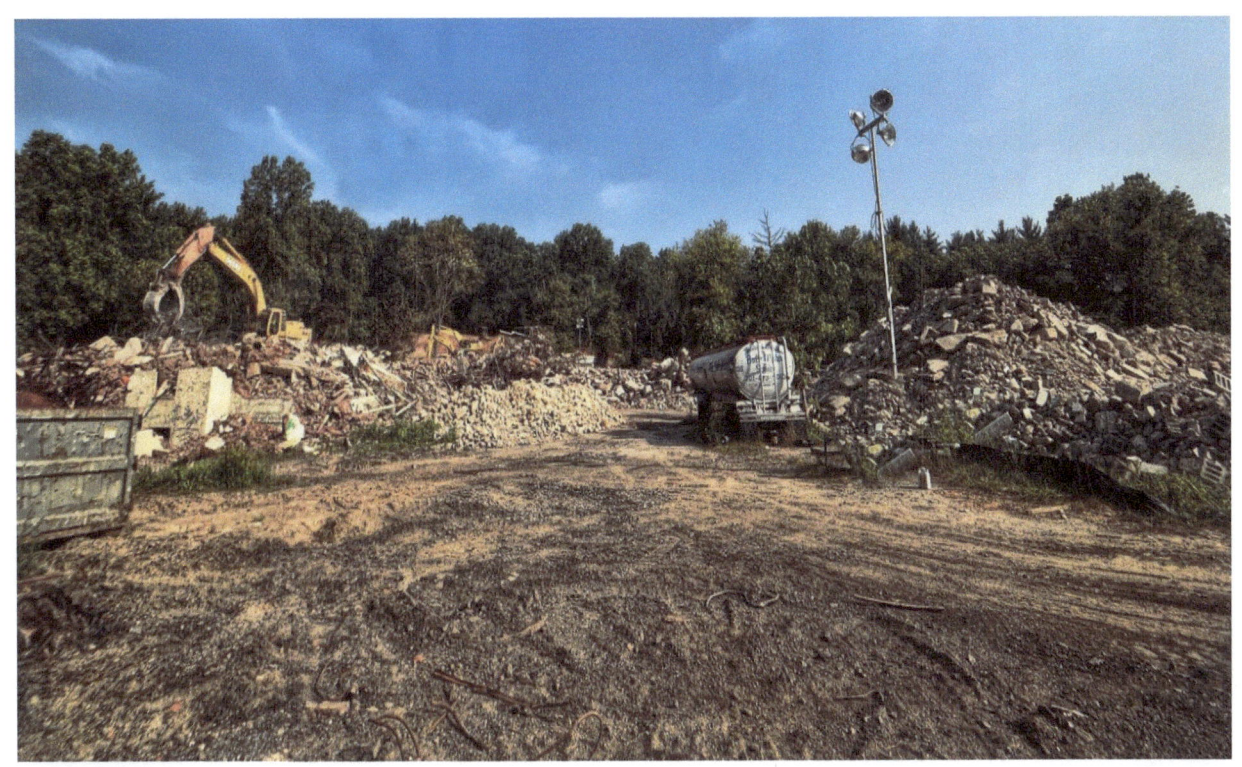

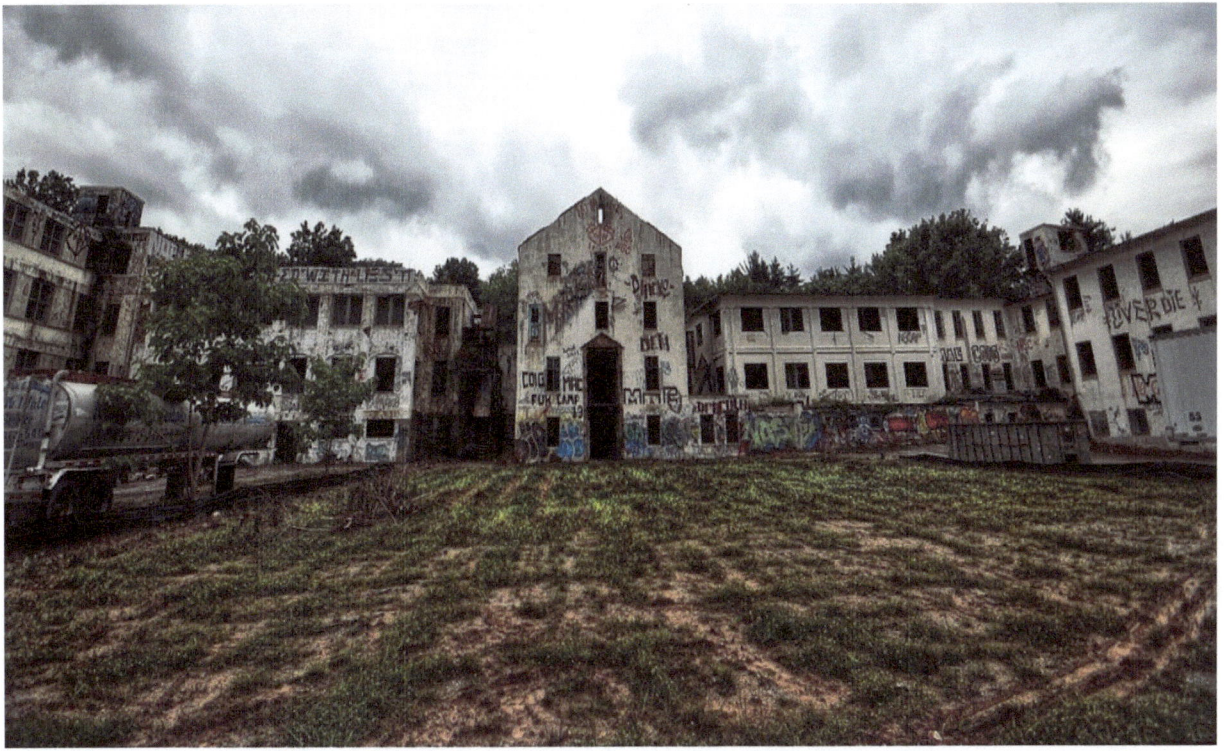

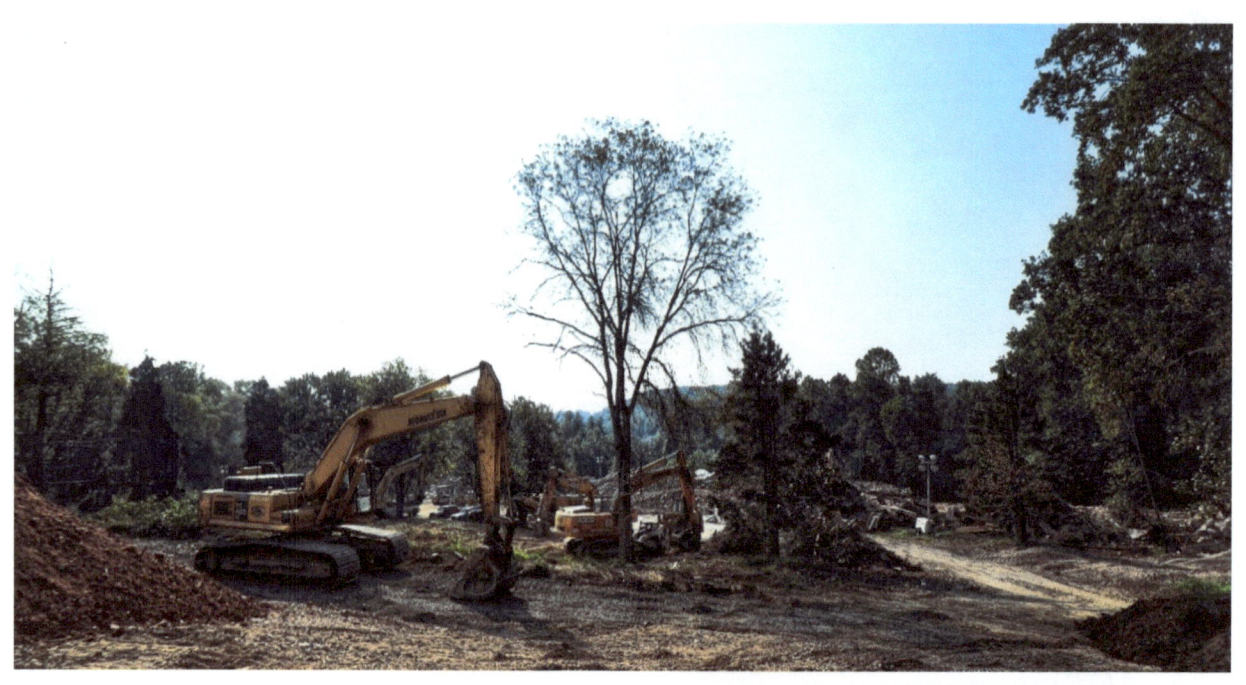

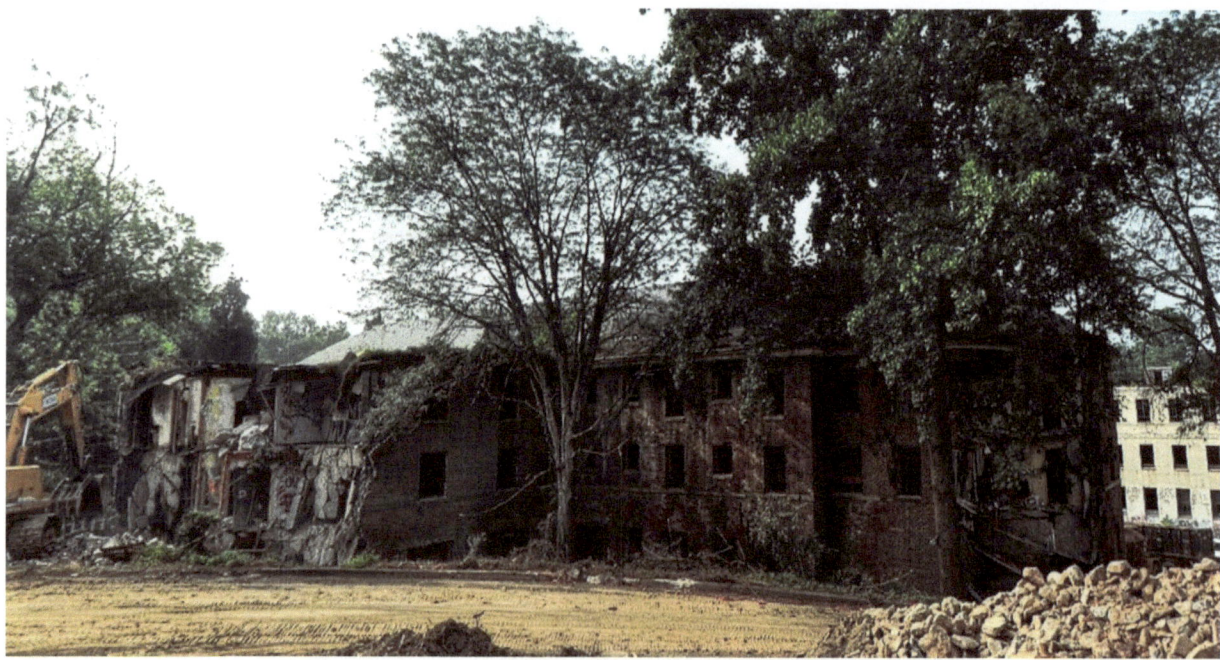

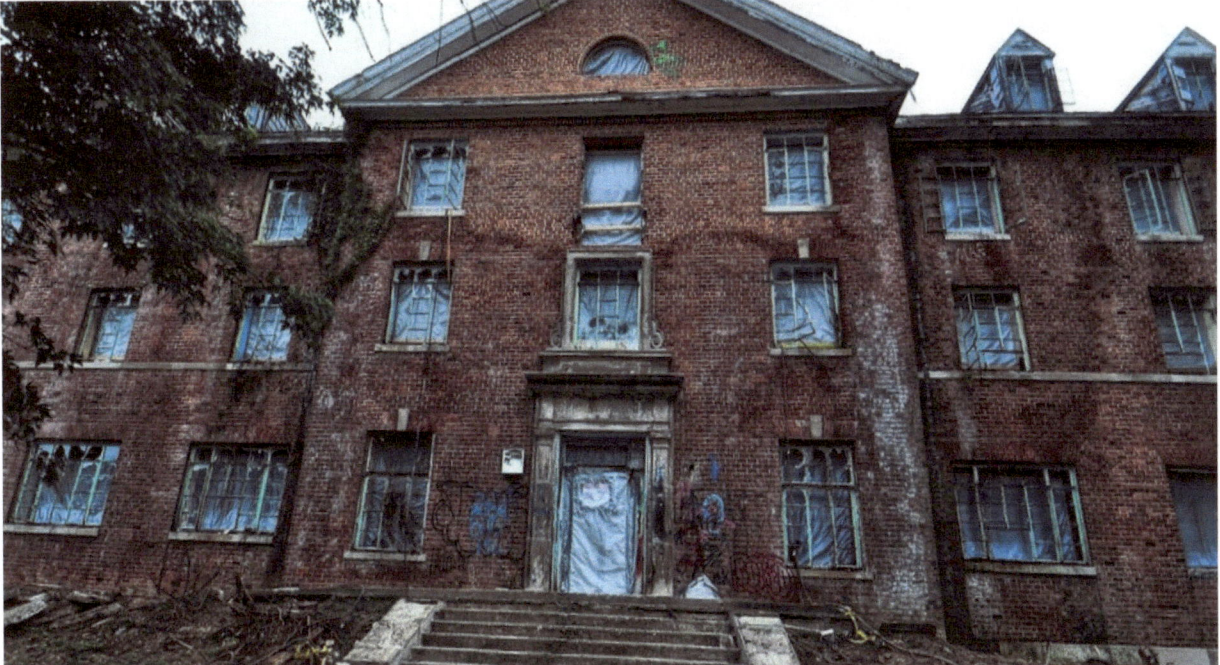

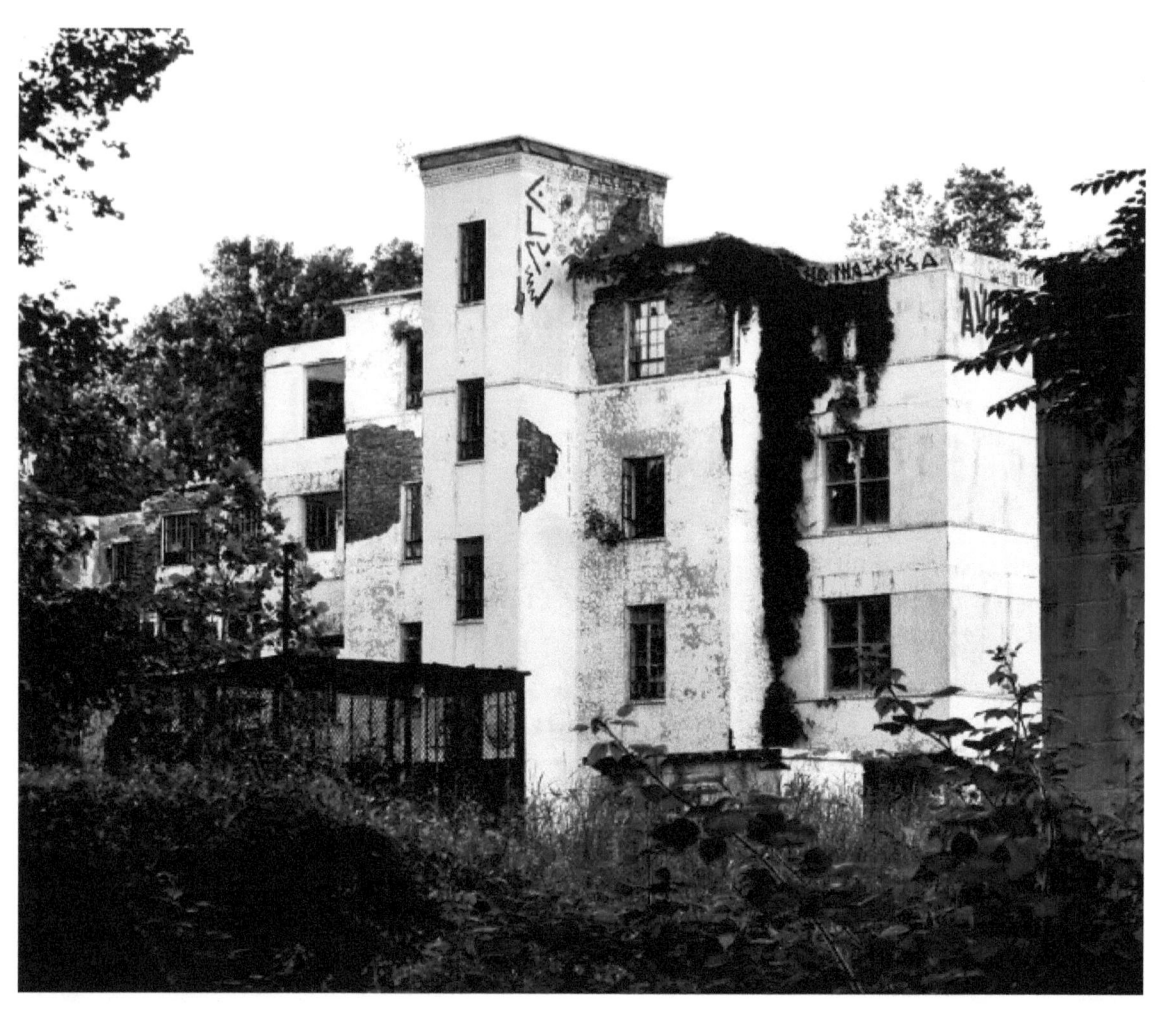
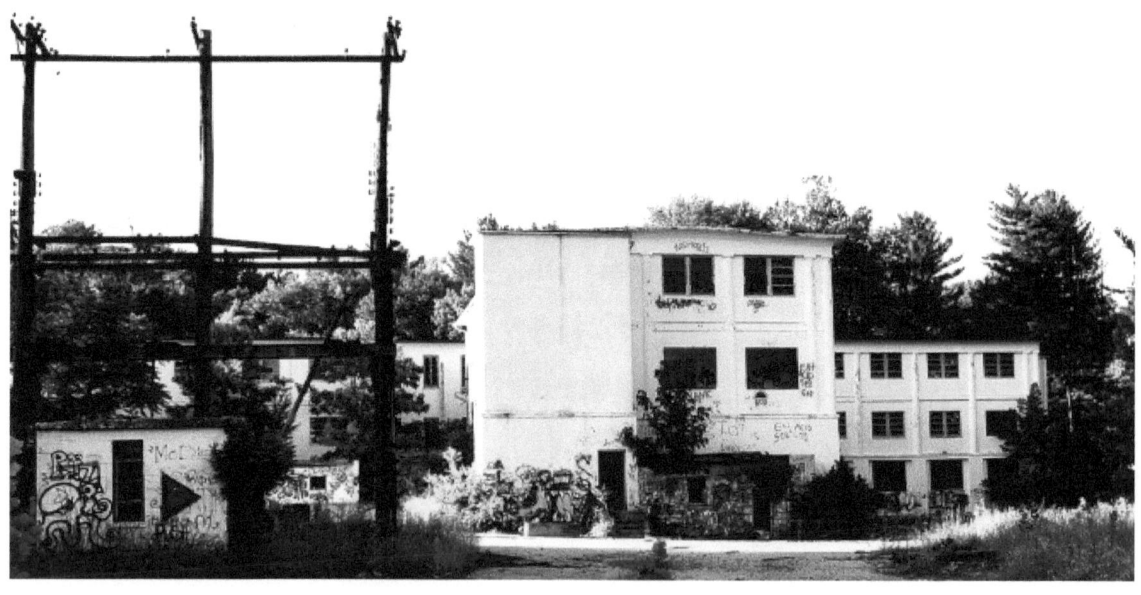

CHAPTER 6 SAVE HENRYTON

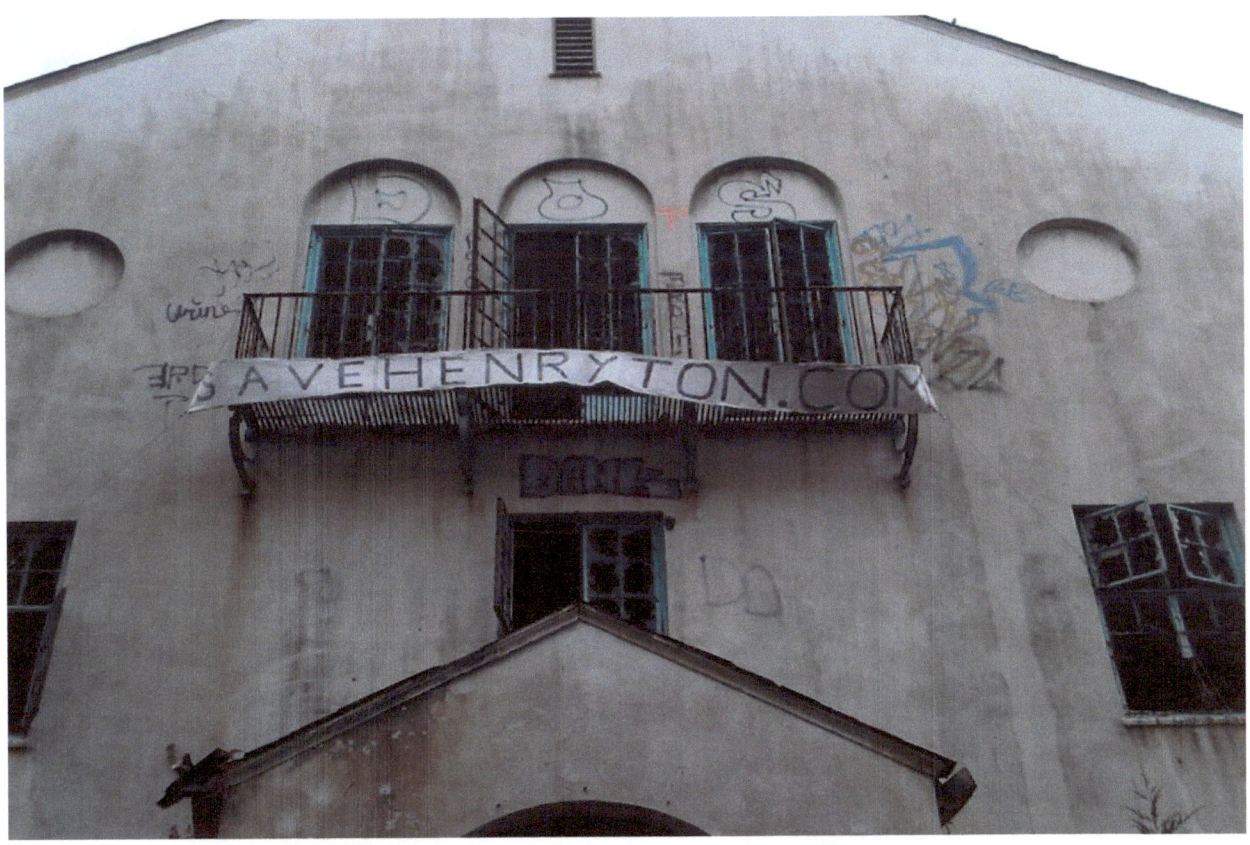

SaveHenryton.Com was the brain child of Ally Hunter-Harris. She started this campaign in 2009. She tried to work with the State of Maryland to come up with solutions to repurpose the buildings and save them. Unfortunately her efforts were not enough to Save Henryton. The buildings were too far gone and vandalized. There was a plan from the State to recycle the brick and other parts from the buildings, using the local inmates When the Engineers House was set on fire, that was the last straw the demolition process was kicked into high gear.. The above photo is from Ally.

Here is a statement from the founder of SaveHenryton.Com:

"After seeing the Henryton campus for the first time, I fell completely in love with it. The buildings were beautiful, the grounds were beautiful, and the more I researched tirelessly, the more I realized that Henryton was wholly beautiful. Upon learning that the state had no plans for the preservation of the property I realized that somebody had to be the voice for Henryton. The idea truly took form in the spring of 2007 on a visit with a friend when I shared my vision with her and by 2008 I had assembled a team and printed several stacks of promotional materials. A LEED-certified contractor even joined us for an informal meeting and he was granted permission to tour the grounds and then reported back to us with an estimate and a game-plan on how to go about the actual restoration. We were thrilled! I finally thought we would see the light at the end of the tunnel in 2010 when I met with a green development firm that told me they were working with the University of Maryland. UM was apparently interested in the property and their firm had told them about us, so

the university green-lit a meeting with the hopes of teaming up. For reasons that were never disclosed to me (the whole project was, for some reason, very hush-hush), the arrangement fell through—Maryland wouldn't even let a local university utilize the property and take it off of their hands! I was disheartened but not discouraged.

As time ticked on, less and less of my emails were returned. Press releases were sent out but never released. I had given up completely on phone calls—even the NAACP couldn't be bothered to respond. I still returned to the grounds from time to time to keep up on the state of affairs and with each visit my heart would break just a little more. When news of the demolition came about I began the process of getting an injunction but a final visit to the grounds in April 2013 just confirmed my worst fears: Henryton was officially beyond saving.

Perhaps the project was too ambitious. Perhaps I didn't try hard enough or exhaust every avenue. Perhaps the fight was too political and I was just unwilling to play politics. Perhaps there was no hope to begin with. The fact remains that the destruction of Henryton by vandals and the subsequent demolition by the state should have and could have been prevented. Maryland lost a huge part of its history and potential was squandered. In a world where "planned obsolescence" is actually a thing, saving Henryton would have made a bold statement to all who were willing to listen. Call me old fashioned but I was raised to believe that if something broke you need not discard it without exploring the possibility of fixing it. To quote John Ruskin's The Seven Lamps of Architecture, "When we build, let us think that we build forever..." August, 2013.

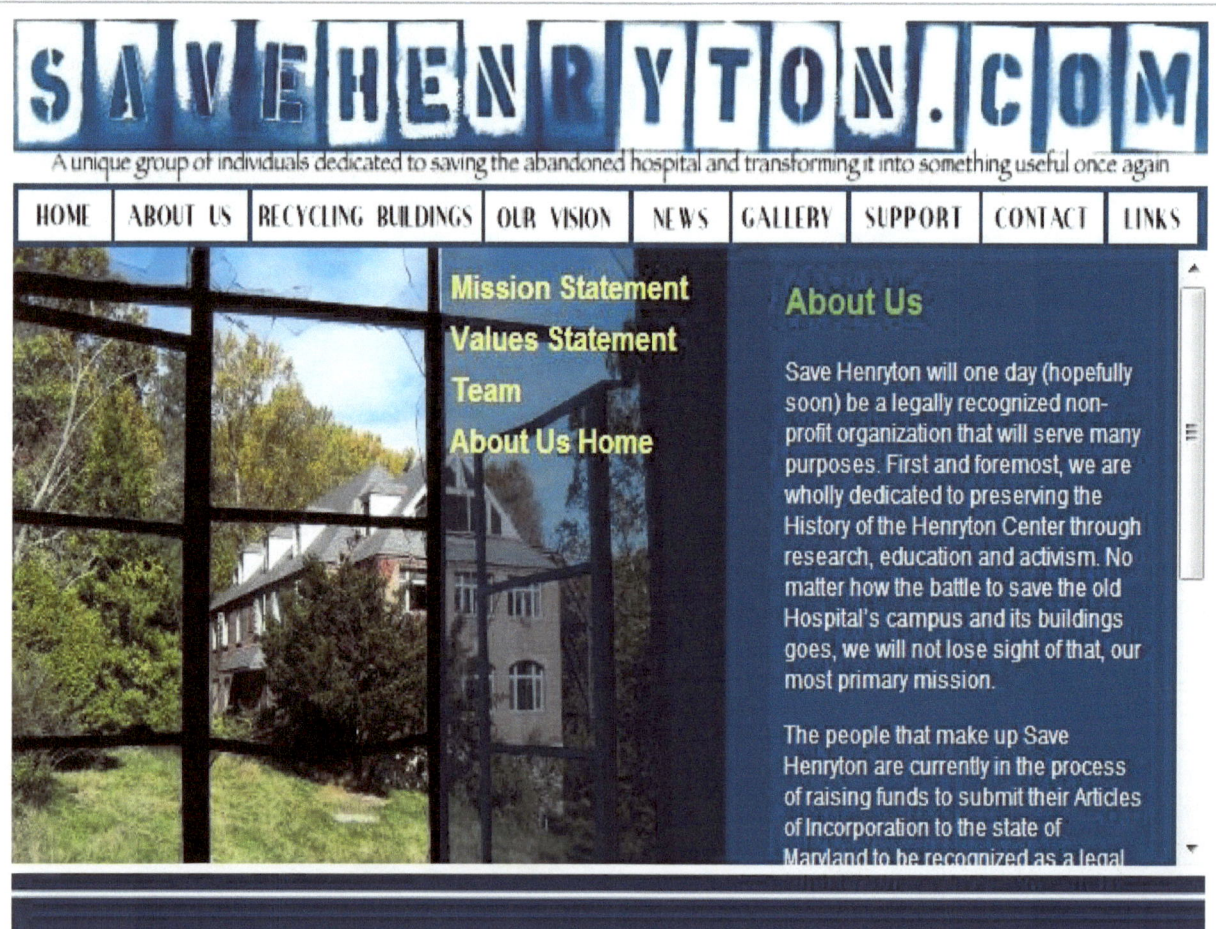

CHAPTER 7 PHOTOS

Henryton Hospital Center was visited by thousands of people over the years. Urban explorers looking for that epic shot have roamed these buildings. Professional photographers have brought models for photo shoots; graffiti artists trying their hands at a clean pallet, vandals looking to steal and destroy everything in sight. Many ghost hunters have gone to find that strange feeling. Scrappers that have opened up all the walls for the copper were arrested here. And finally, the curious people that just love the place. Below are photos from friends. All which had a good feeling about Henryton and a photographic connection. We hope you enjoy all their art over the years.

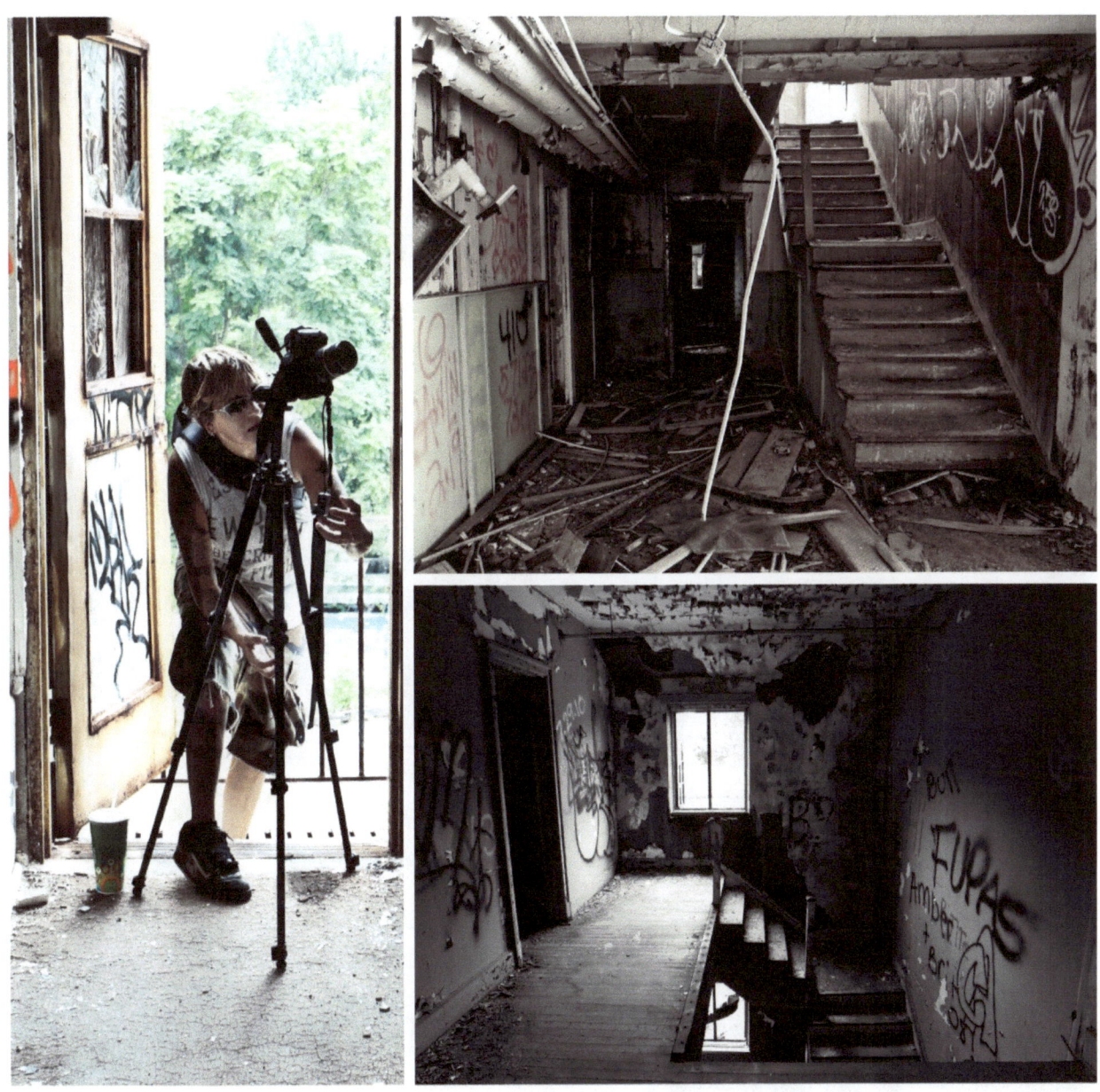

Photos taken by Nathan Kay. Pictured is Dawn Robinson taking a photo.

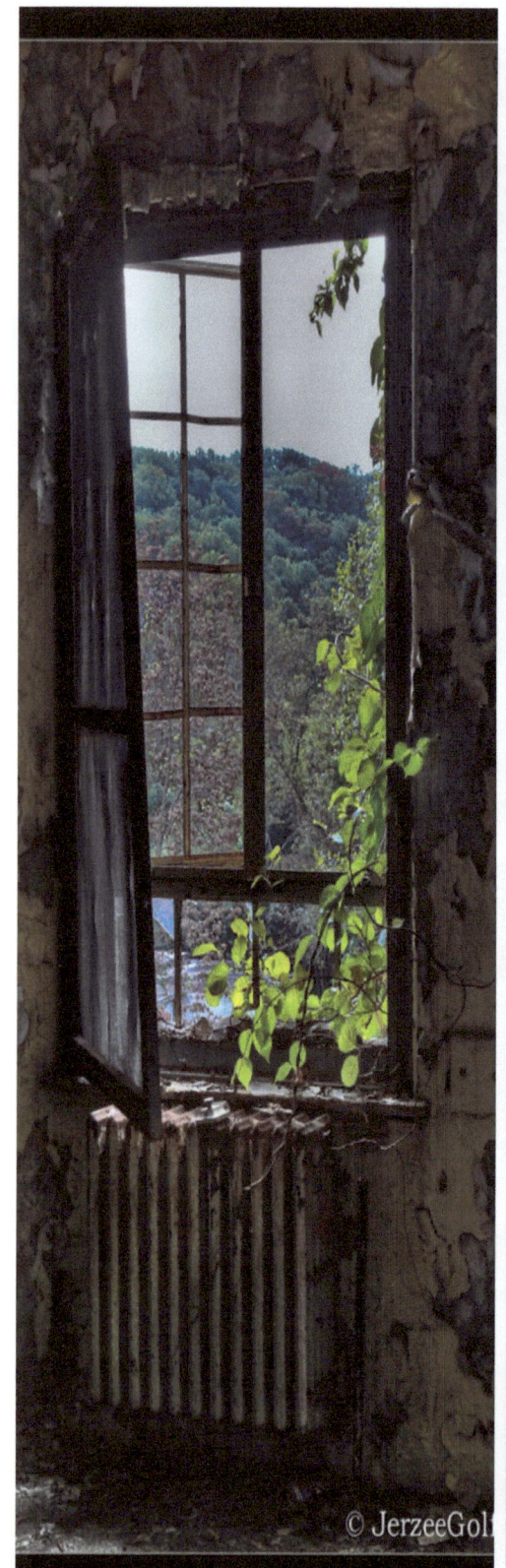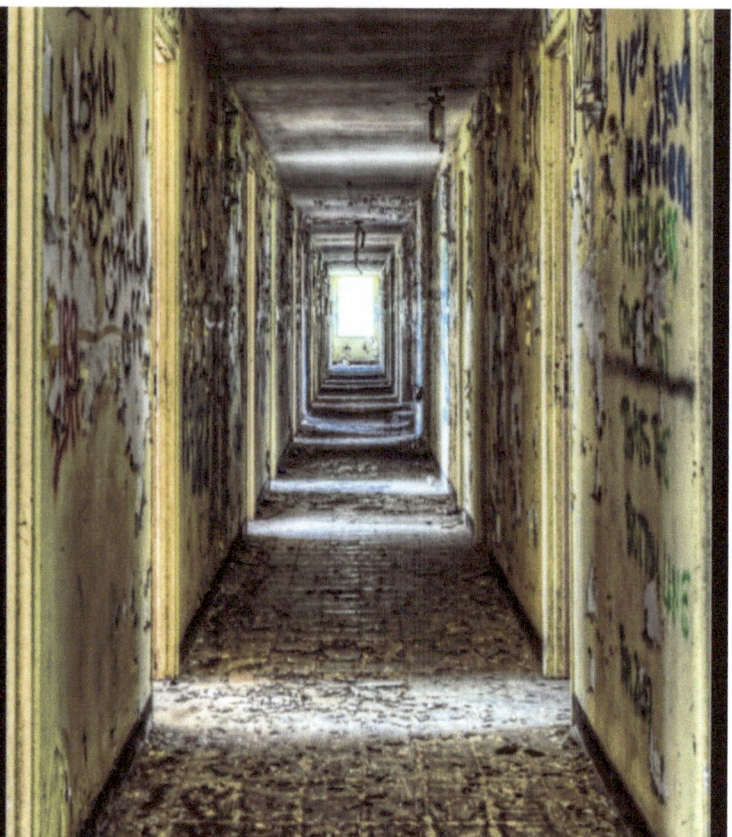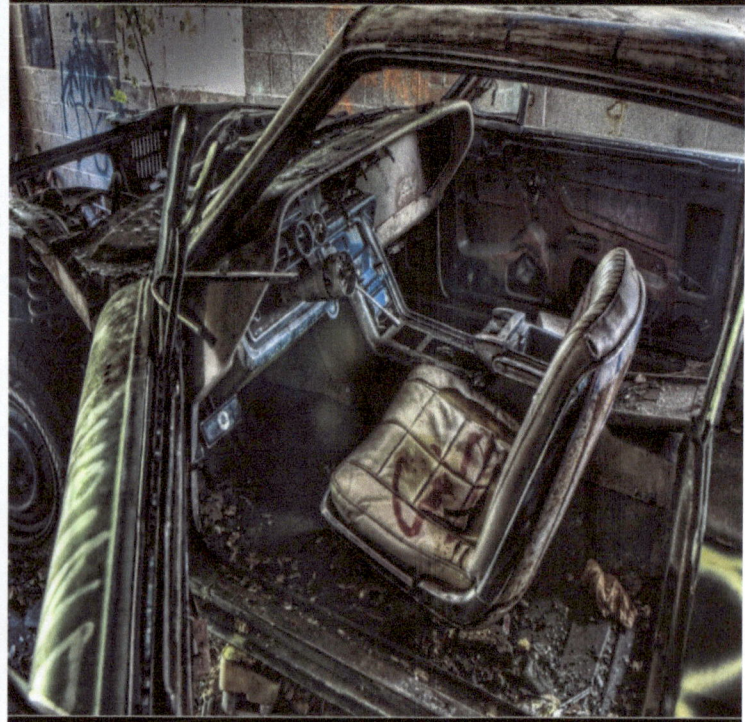

Photos taken by Deborah Felmey. The car was from the maintenance shop, or garage.

Photos taken Betty Fowler.

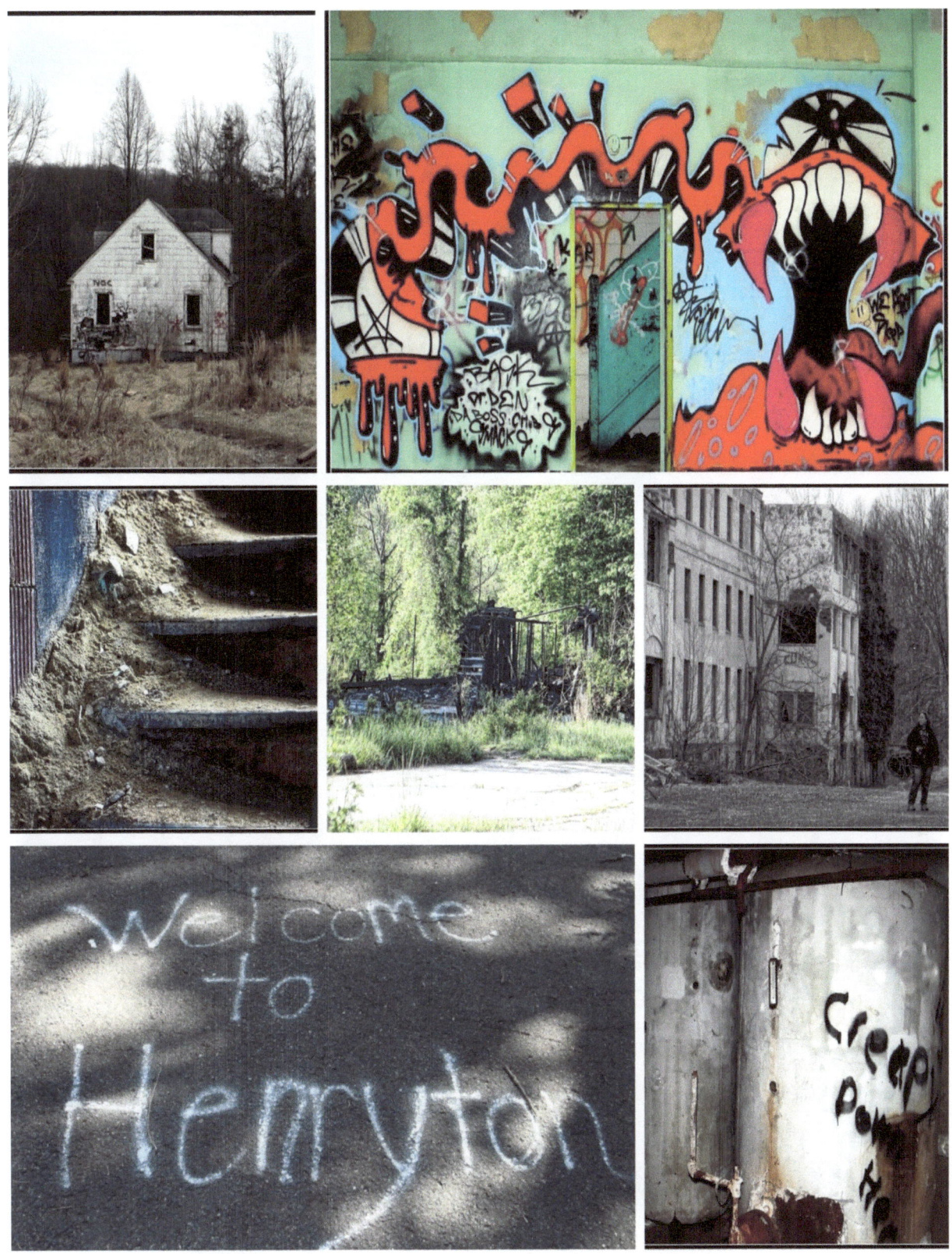

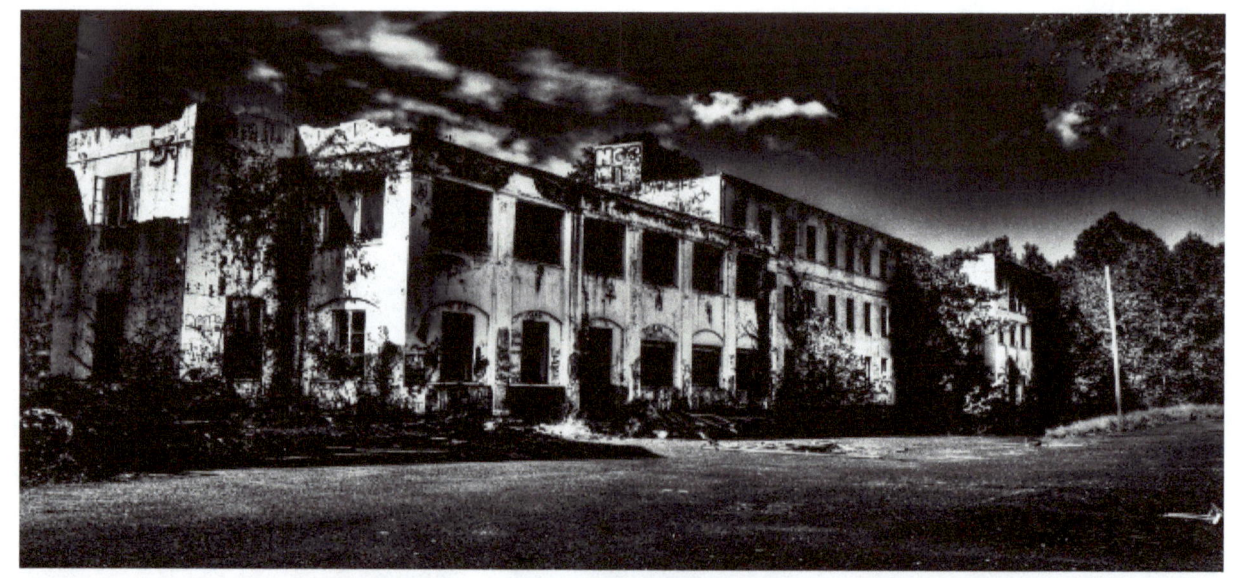

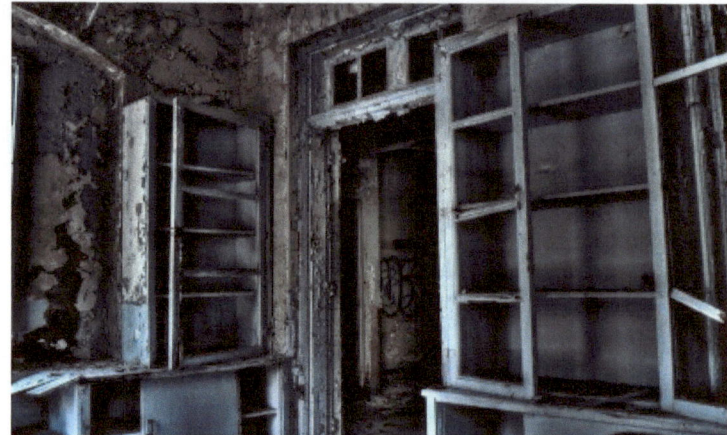
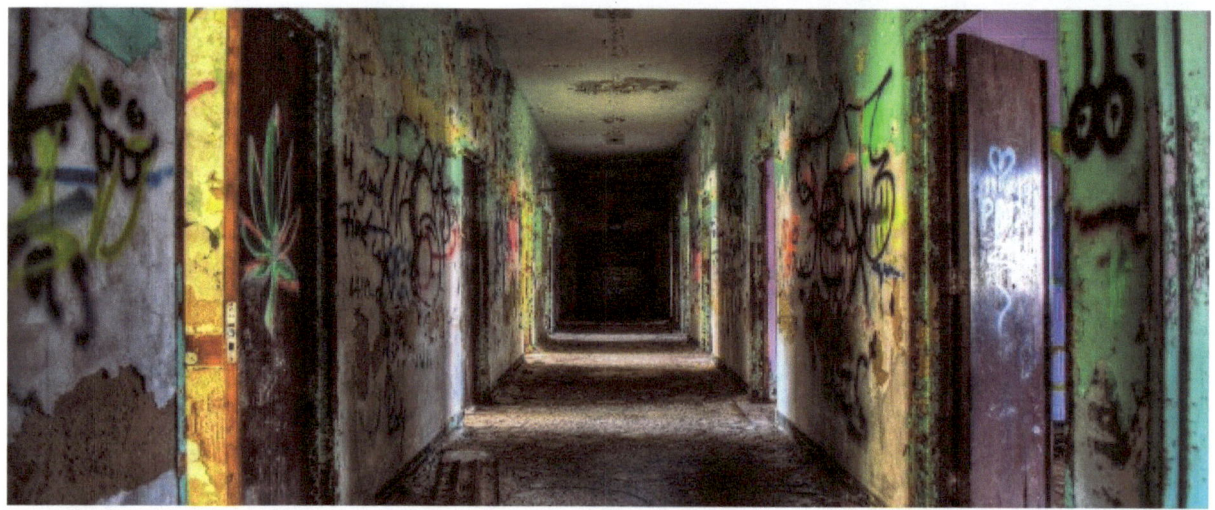

Photos taken by Liz Cusick

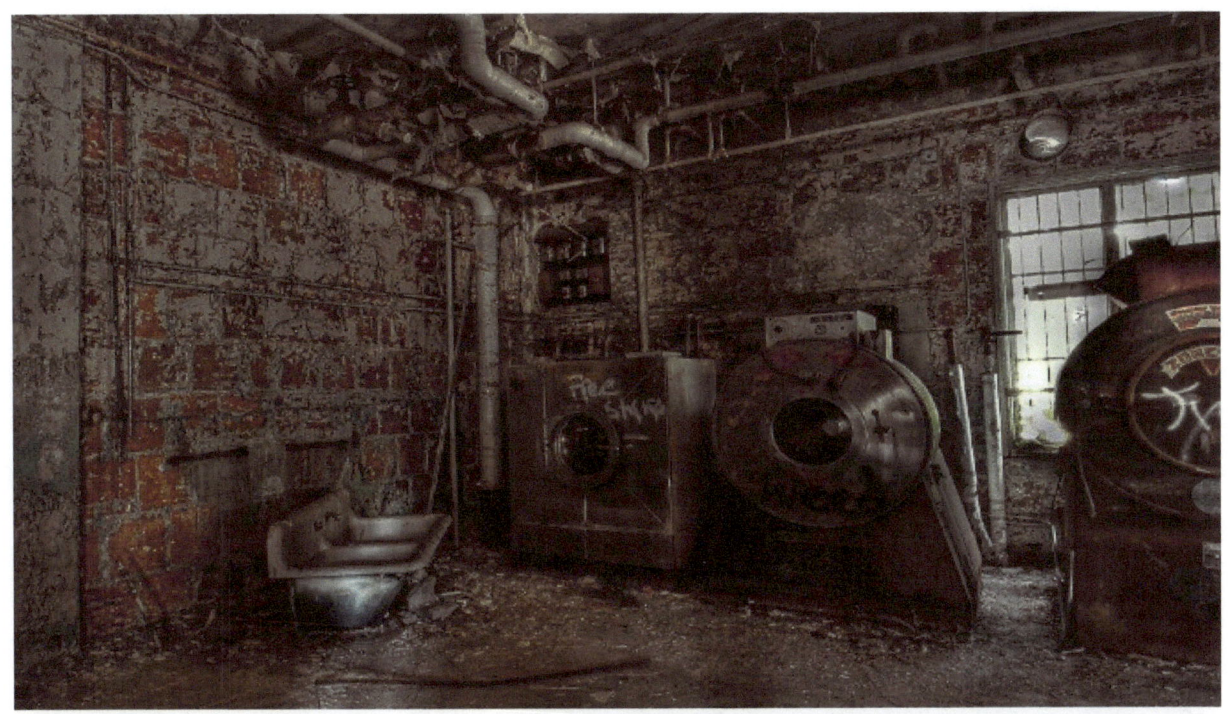
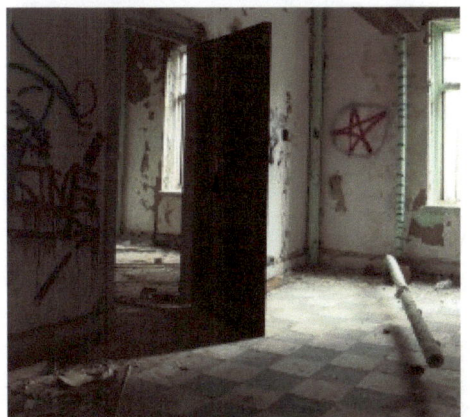
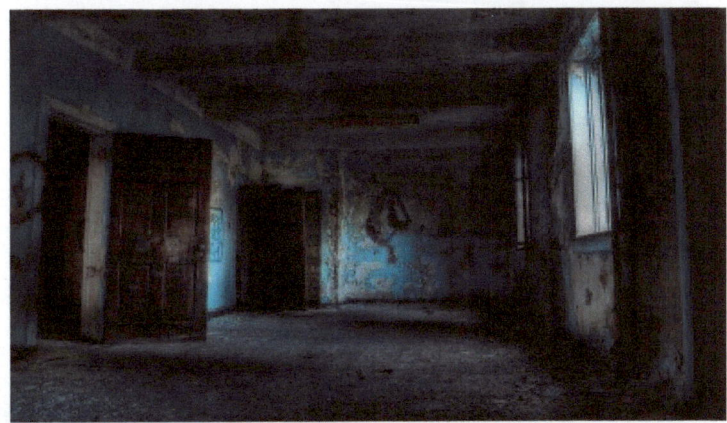
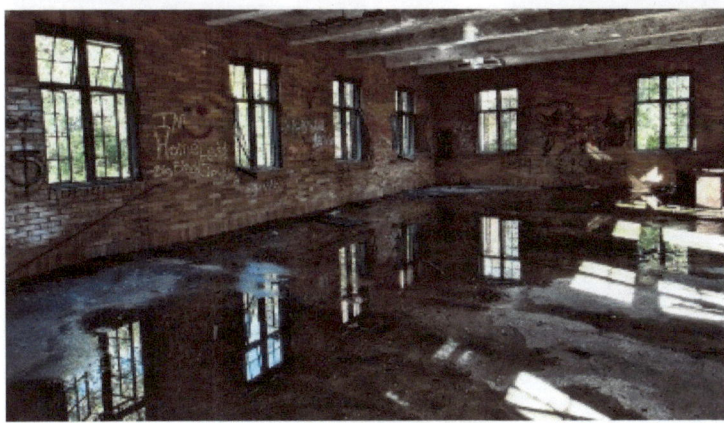
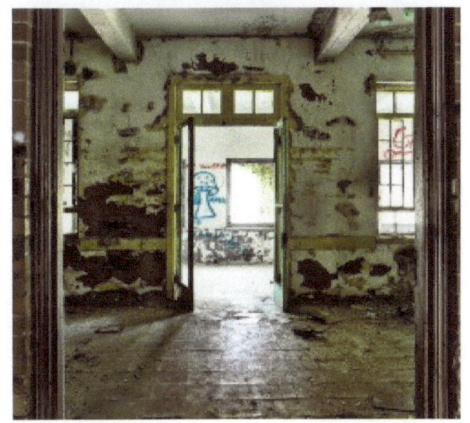

Photos taken by Tim McGovern

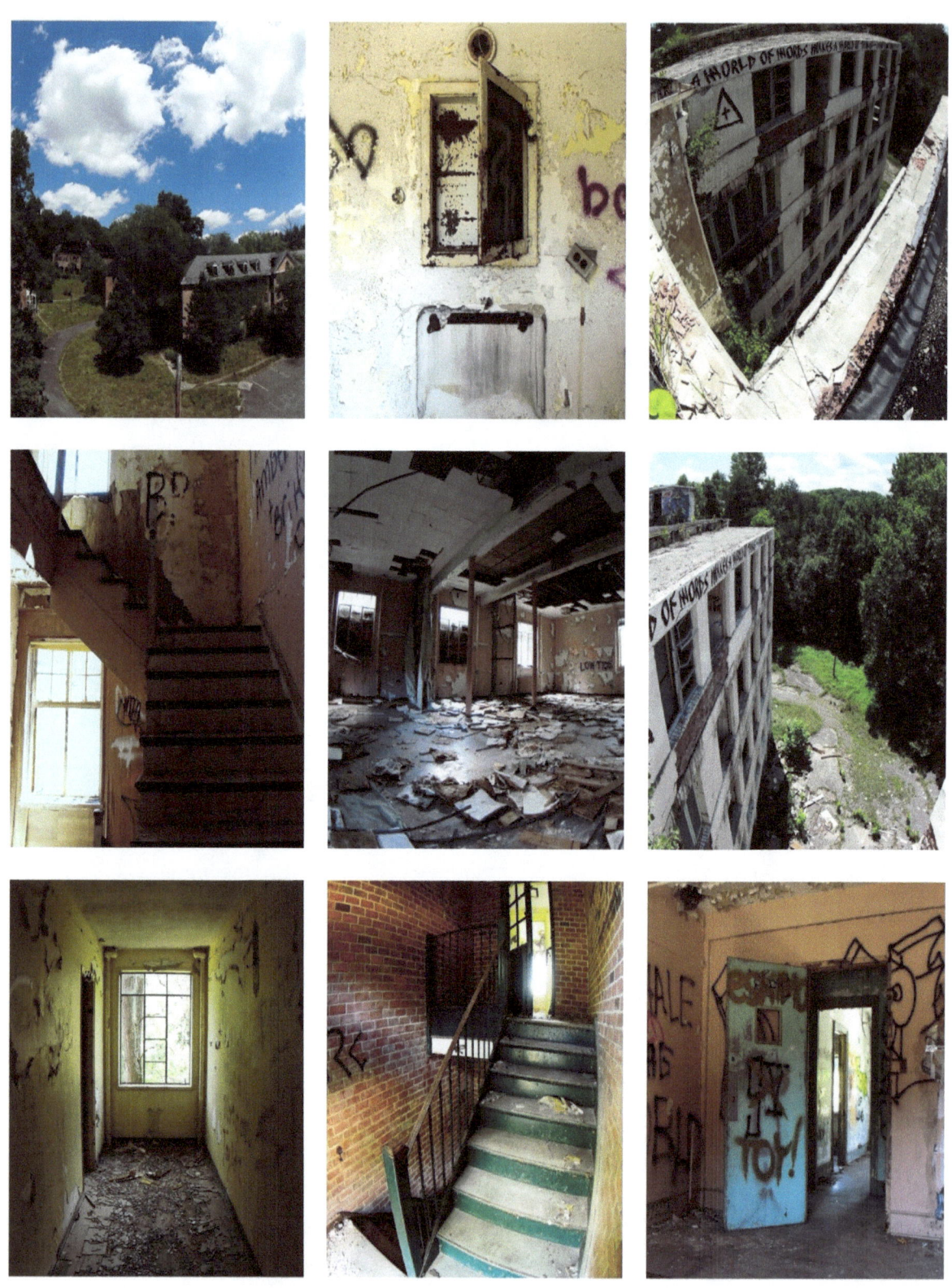

Photos taken by Guy Housewright August 2011.

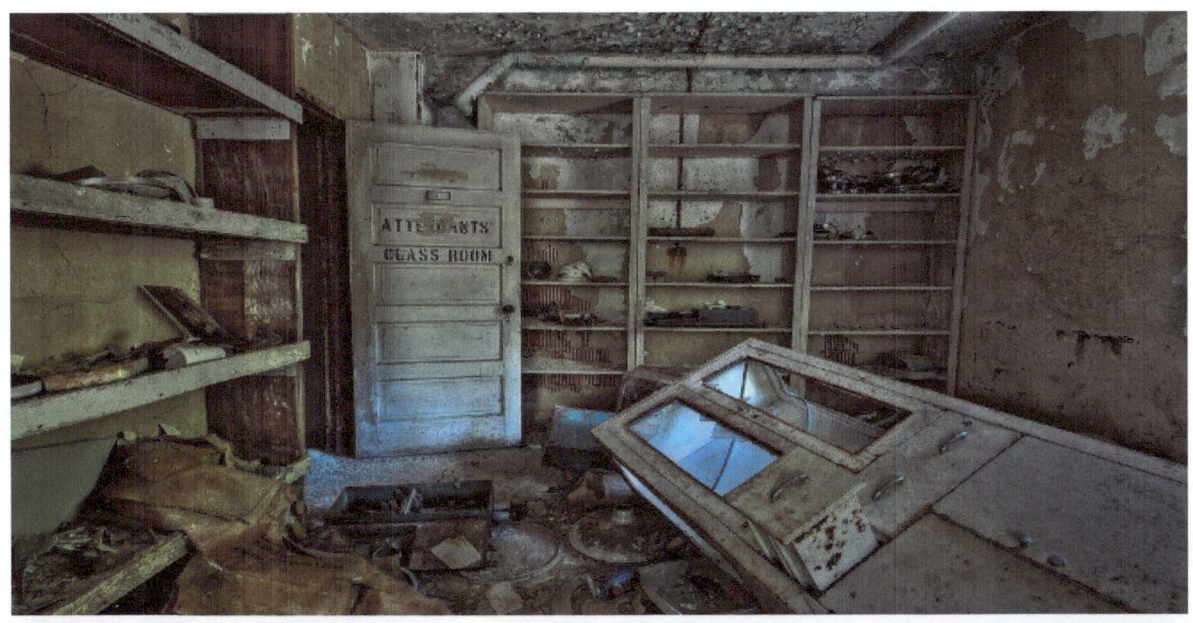

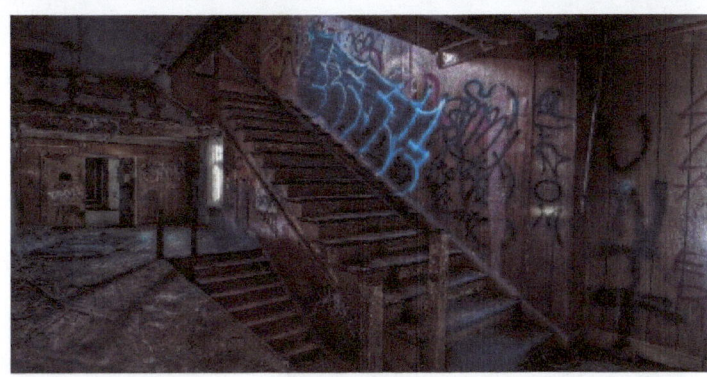
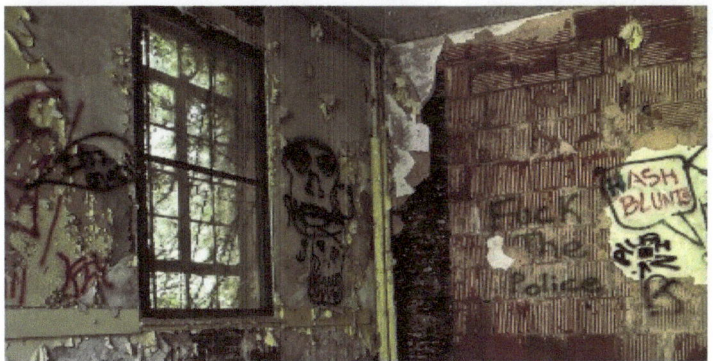

Photos taken by Tim McGovern.

GROUP SHOTS THROUGH THE YEARS

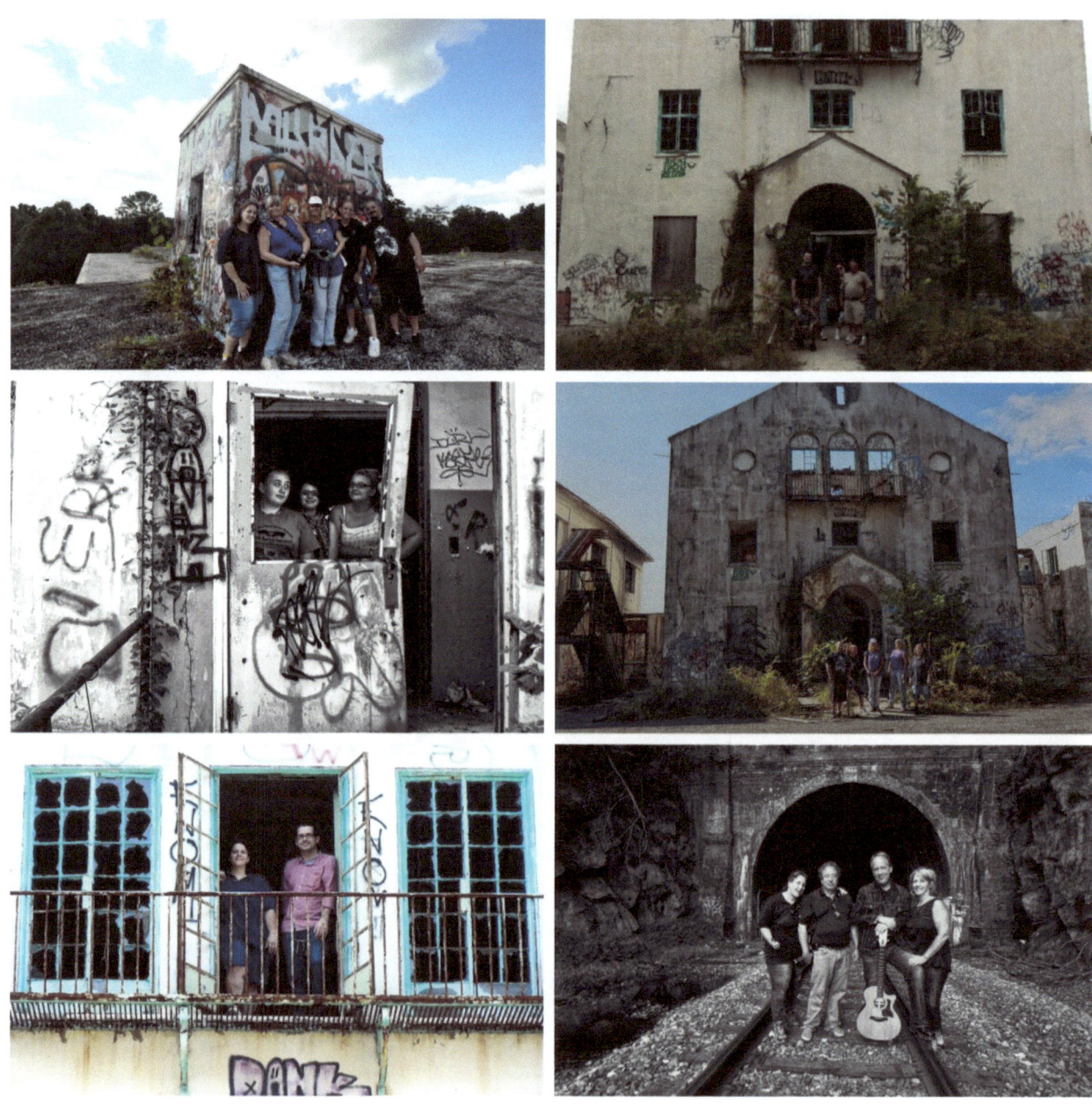

CHAPTER 8 NEIGHBOR OF HENTYRON

Have you ever driven by an abandoned building, house, and factory and wondered what happened there? Why it was abandoned, left behind to decay and Mother Nature surround it with vines? The curiosity of these places has always fascinated us. After my daughter introduced us to Henryton, our photography started. We wanted to capture all the decay and beauty. Then we were curious of who lived there and who worked there. I started to research by address, sanborn maps, and Google maps. There was always something about Henryton and the different buildings they always drew us back to visit and photograph the different times of the day. No two photographs looked the same. This is all about the Henryton Project.

In my research, I came across a neighbor, Bill Oursler, he grew up on the land next to Henryton. We became internet friends and have emailed for over two and a half years stories about his life and what he saw as an outsider from the hospital. He is now 82 years old and sharp as a tack. I call him "Wild Bill".

Original Post I found : StrangeUSA.com68.35.0.145 Comment# 8773 1/25/2008 8:46:00 PM
I grew up around Henryton, Md. I am nearly 77 years old, but remember well walking to the boiler room of the Henryton Sanitarium every Sunday morning to get the Baltimore Sun Newspaper. The Hospital wasn't nearly as interesting to me as the tunnel was. Many times I have walked through that tunnel to Marriottsville. As a kid I did go into the Hospital with some of the kids around the area now and then and watch movies on Sat. night. Anyone could go in the theater for free.. Right north of the buildings was a graveyard. Many of the patients were poor and had no people, so they were buried right there on the grounds. Some have said the small burg was named after John Henry, The black steel-driving man. He is the one that beat the steam-drill through a tunnel. The problem is that, John Henry wasn't driving steel until the 1870. The Henryton tunnel was built in 1850. Anyway, the thoughts of Henryton and Marriottsville and the tunnel bring back memories. I never knew about any ghostly stories in the 1940's as the sanitarium was in operation at that time. I enjoyed living in Maryland ……........... That Hospital was always run down and dirty even in its best days....Many, many people have died there. If I believed in ghosts, I would say that the anguish of the suffering sick ones with TB were crying out. I didn't go around the hospital very much as I was afraid of catching TB......Bill

Not knowing is he was still active online, I emailed him. And a few days later this is what I received:

From: BILL OURSLER

Sent: Dec 22, 2010 03:36:42 PM

Hi Amy, Glad to hear from the folks back home. That's right, I not only grew up around Henryton, almost in it. Our property bordered the Sanitarium property. One little correction on that internet mail. Henryton Hospital was the pride of the state when it was first built. It got shabby in the late 40's and 50's when it knew it was in its last days. In the 60's when it became an institution for the criminally insane it really went to pieces. Even now, it has a thing of the past beauty all its own. I am very upset about what the vandals and bums have done to it. The tunnel is my favorite there what specifically did you want to know about Henryton? I'll try to tell you…….…….Ah, yes, Eldersburg. It was just a cross road of the Liberty Rd from Sykesville to Westminster when I was young. Best wishes, Bill

Wild Bill used to go to the Henryton Power Plant every Sunday morning and get the paper. There was always candy waiting there for him. He was not allowed to get any closer than that for fear he would catch TB. He used to sit on the hill across from the Nurses Cottage in the woods and listen to the singing at night. The patients would perform plays for each other. He said they were very talented.

Wild Bill sent me stories of a few train derailments that happened near the Henryton Train Tunnel. One took out Mrs. Smith's House. He said the steam engine trains would go so fast past his house that they call them the iron horse. There used to be many smaller houses around Henryton that over the years were taken down by the State of Maryland. One particular house still has the basement remains on the property. The State of Maryland called it a "bunker". After research, Betty Flower located a photo of the house. Not many people that visited Henryton in the recent years have ever seen this Henryton. Bill Oursler sent these photos to me. The trains are from 1941, passing Henryton. That is Bill on the giant bike at age 17, picture left.

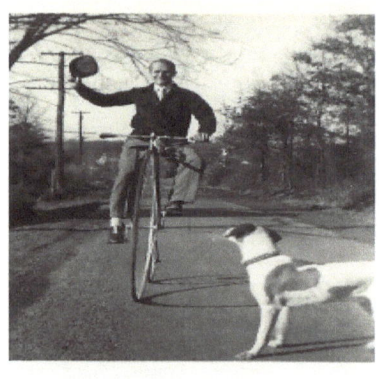

CHAPTER 9
Random Shots

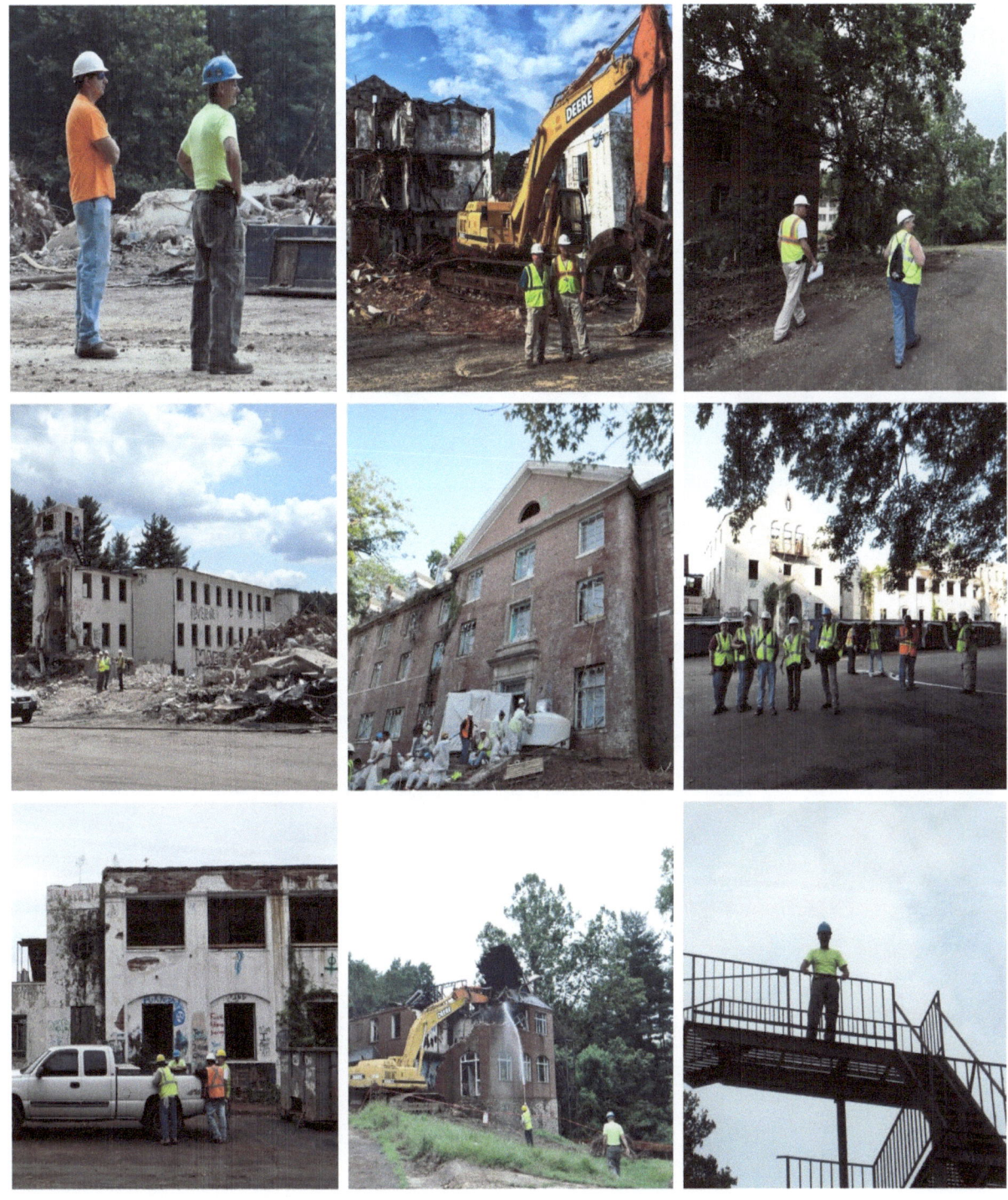

CHAPTER 10 – ABOUT THE AUTHOR

Amy and Timothy McGovern have been exploring forgotten places for a few years together. Their love for the abandoned came from hiking and finding old empty houses and barns. This grew into their curiosity for the history of buildings and Forsaken Fotos. Please visit their website: www.forsakenfotos.com

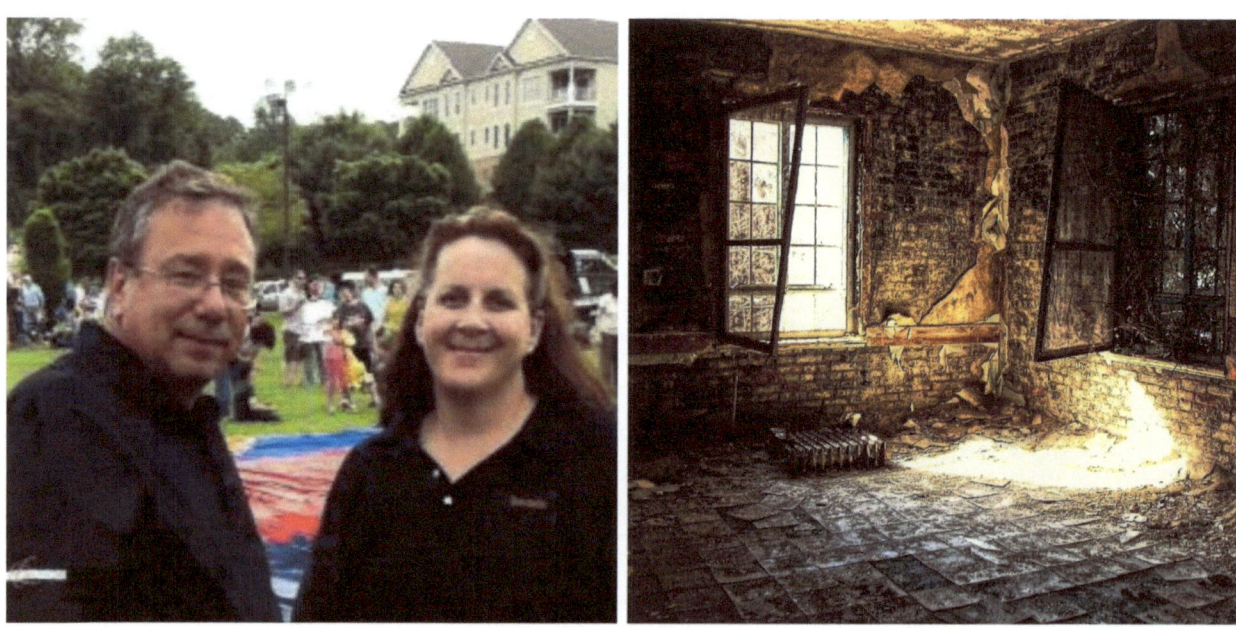

Copyright © 2013 Amy McGovern & Timothy McGovern 8-2013

All rights reserved.

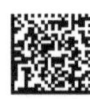